ARK

⟩THE ARK PROJECT⟨
by DGPH

AN ILLUSTRATED ANIMAL BIBLE
BY ARTISTS FROM ALL OVER THE WORLD

BASED ON A PROJECT CREATED BY DGPH
AND PUBLISHED BY IDN

www.TheArkProject.com.ar

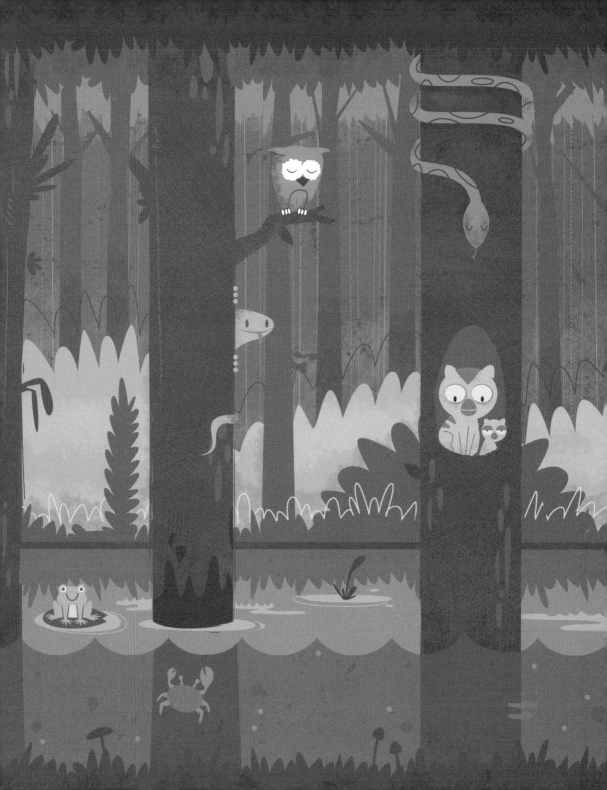

"And of every living thing of all flesh, two of every sort shalt thou bring into the ark, to keep them alive with thee"
GOD to NOAH, Genesis 6 - 19

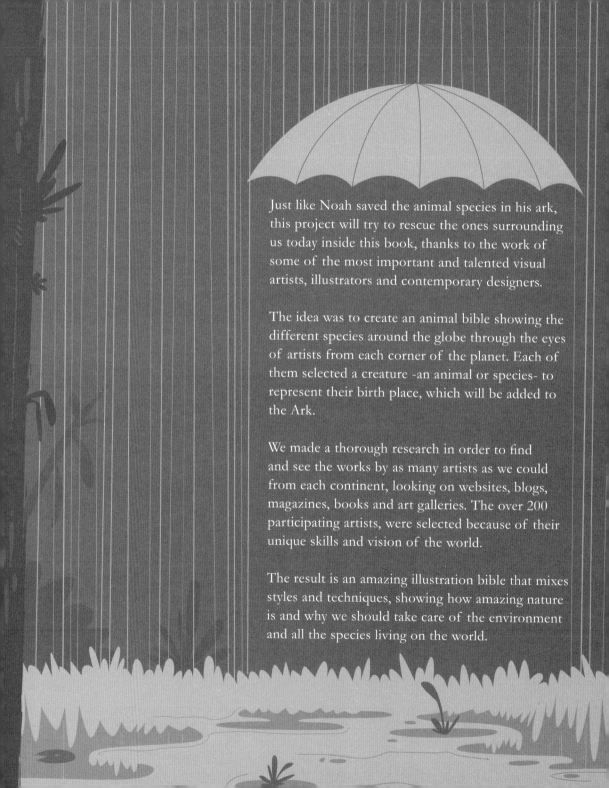

Just like Noah saved the animal species in his ark, this project will try to rescue the ones surrounding us today inside this book, thanks to the work of some of the most important and talented visual artists, illustrators and contemporary designers.

The idea was to create an animal bible showing the different species around the globe through the eyes of artists from each corner of the planet. Each of them selected a creature -an animal or species- to represent their birth place, which will be added to the Ark.

We made a thorough research in order to find and see the works by as many artists as we could from each continent, looking on websites, blogs, magazines, books and art galleries. The over 200 participating artists, were selected because of their unique skills and vision of the world.

The result is an amazing illustration bible that mixes styles and techniques, showing how amazing nature is and why we should take care of the environment and all the species living on the world.

ARK
.BOOK CONTENTS.

INDEX

Iconography

 Mammal Amphibian

 Bird Molusc

 Fish Arthropod

 Reptile Extinct

More information
www.TheArkProject.com.ar

6.760.000.000

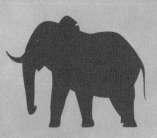

600.000 ELEPHANTS SLAUGHTERED
IN THE 1970s – 1980s

IN 2006 23.000 ELEPHANTS ILLEGALLY KILLED

IN 2 DECADES AMAZON RAINFOREST
WILL BE REDUCED BY

40 PERCENT

THE REGION IS HOME TO
2.5 MILLION INSECT SPECIES
2,000 BIRDS AND MAMMALS
TENS OF THOUSANDS OF PLANTS

INDIA
BENGAL TIGER POPULATION IS NOW ESTIMATED BETWEEN
1.300 / 1.500

3 SUBSPECIES ARE ALREADY EXTINCT

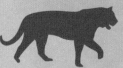

+100.000 BIRDS. WHALES TURTLES & SEALS
KILLED EVERY YEAR by PLASTIC BAGS

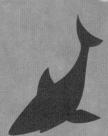

73.000 SHARKS
KILLED EVERY YEAR

500.000 WHALES
KILLED EVERY YEAR

KNOWN VERTEBRATE **EXTINCTIONS** IN THE PAST 500 YEARS
+200 SPECIES

+750 SPECIES FACING EXTINCTION

* HABITAT LOSS, COMMERCIAL EXPLOITATION & THE INTRODUCTION OF INVASIVE SPECIES HAVE INCREASED THE EXTINCTION RISK *

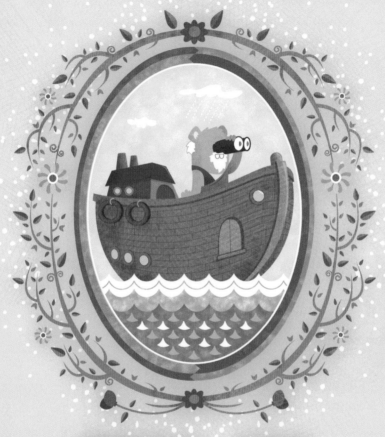

·NOAHs ARK·

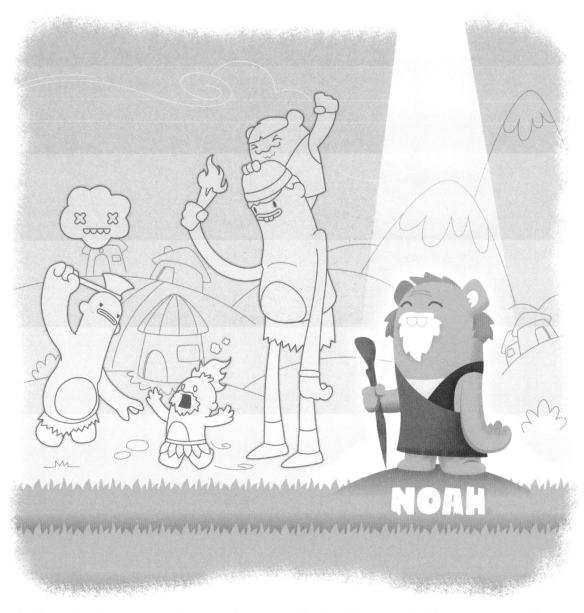

In a little village lived an outstanding man. He was not selfish, he did not steal, he did not swear or attack his neighbours. His name was Noah and he was the only good man in the village; a peaceable man who cared about others, who loved and protected his family.

One day God talked to Noah, "Noah, I am tired of your neighbours. They are selfish, evil and they do not share anything with the needy. "Noah answered, with an absent gaze. "What do you want me to do, my Lord?" "You shall build an Ark for me and I shall clean the Earth with a deluge, but you and your family shall be safe together with all the creatures from this world. "

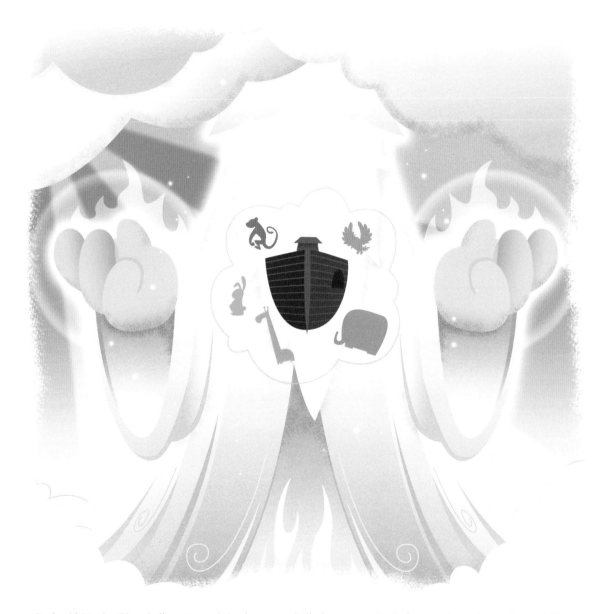

God told Noah, "You shall create an Ark where you shall place two animals from each species in the world". Noah paid close attention to the instructions. "And you shall tell your neighbours about the flood. Those who trust and have faith shall be saved."

Noah and his children set to work on the Ark, gathering wood and thinking about how to place species inside the gigantic ship. It took a long time but they managed to create a design according to the needs the Lord had posed. The whole family collaborated on the development while their neighbours looked in astonishment.

Despite Noah's oft-repeated warning nobody in the village believed what he said.
"What are you doing, Noah? Do you really believe that the world is going to flood?" His neighbours told him.
"Are you really going to lock yourselves up in a boat full of stinking animals for no reason?"

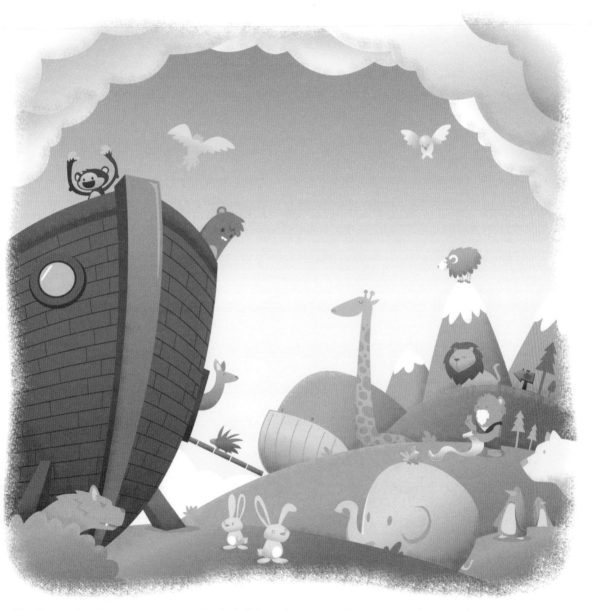

Finally, one day the construction was finished. A huge frame awaited the arrival of thousands of creatures from every part of the world. Little by little each species got on the Ark and took their compartment. Once the Ark was full and Noah's family was safe inside, God closed its doors.

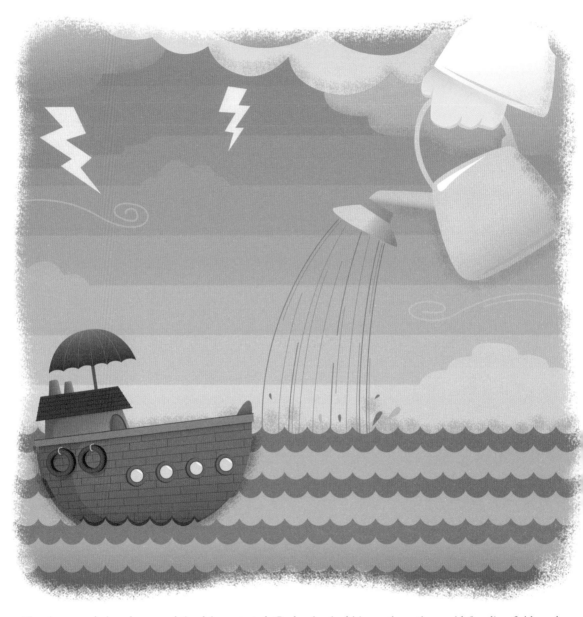

The sky went dark and grey and the deluge started. God unleashed his wrath on the world flooding fields and prairies while the Ark sailed in the great ocean that was forming. Noah and his family were safe inside.

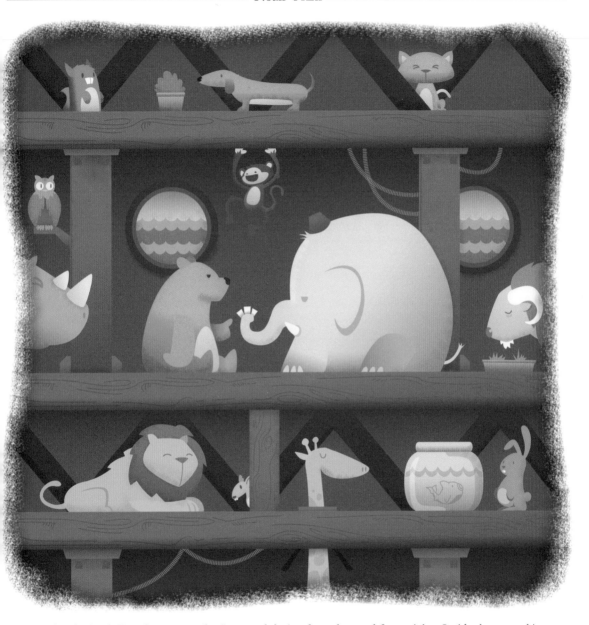

It rained and rained. Days became weeks. It poured during forty days and forty nights. Inside the great ship animals waited patiently to go back to their lands, their pastures and woods and so did Noah's family.

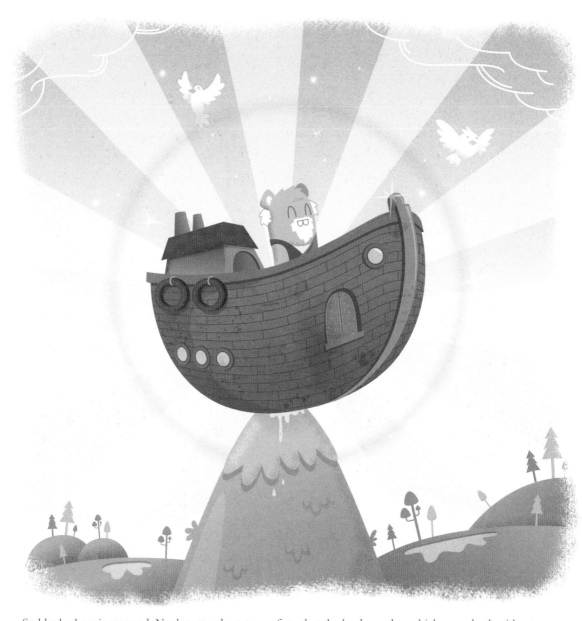

Suddenly the rain stopped. Noah sent a dove to confirm that the land was dry; which came back with a tree leaf, as a sign that the water had disappeared. Everyone was really excited. "We can finally go out! Open the Ark doors and free all the animals."

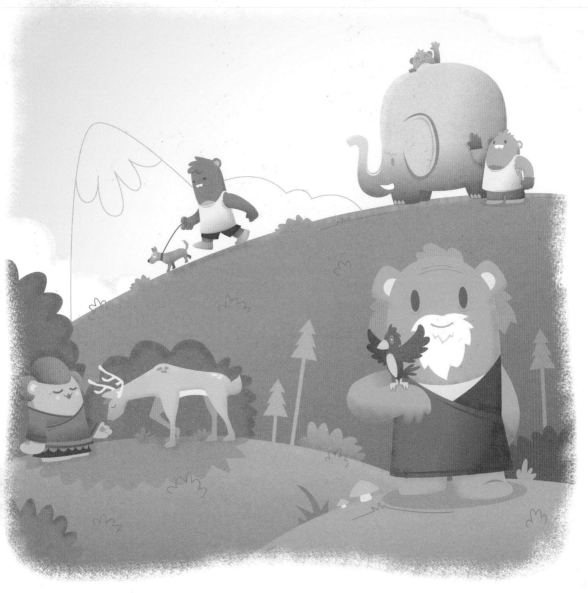

Animals went back to their lands, birds started building their nests and fish swam into the rivers and lakes that the flood had created. God promised Noah never to send a deluge again. And so Noah started to build a new village, a village free from all evil, together with his family.

· *The End* ·

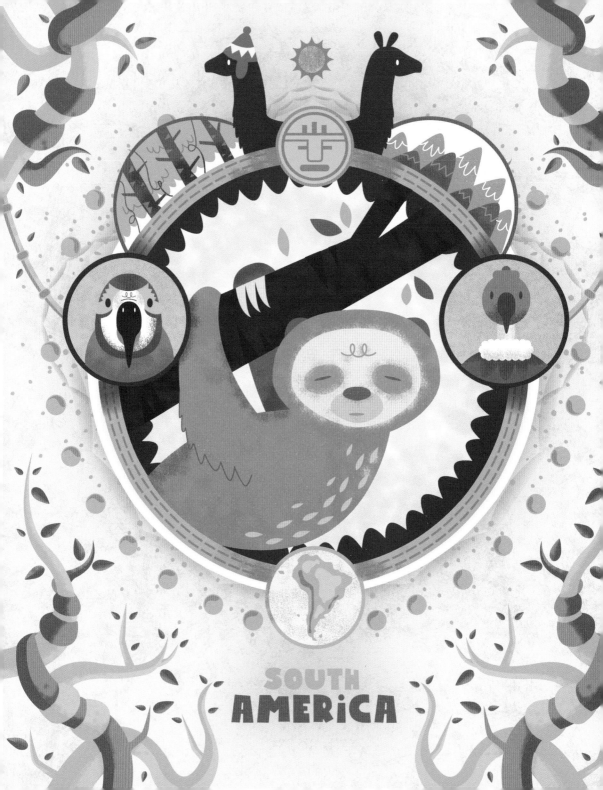

SOUTH
AMERiCA

AGUARA GUAZU *(Chrysocyon brachyurus)*

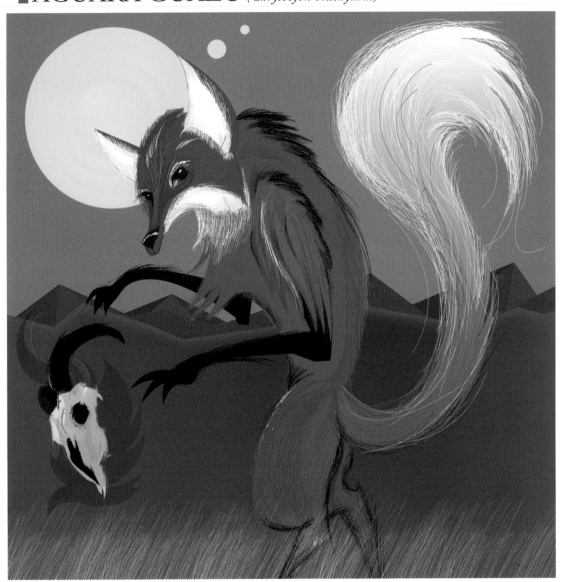

PO!.Argentina
www.patriciooliver.com.ar

ANTEATER *(Cyclopedidae)*

MOPA.Brazil
www.estudiomopa.com

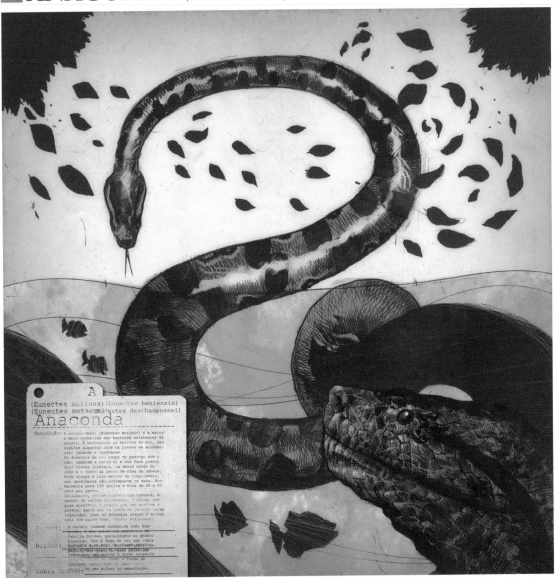

ARMADILLO *(Priodontes maximus)*

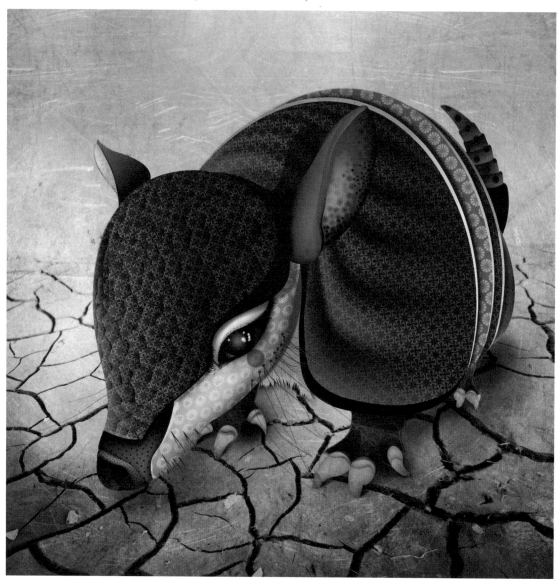

MISS RUIDO.Uruguay
www.missruido.com

BLUE & YELLOW MACAW *(Ara ararauna)*

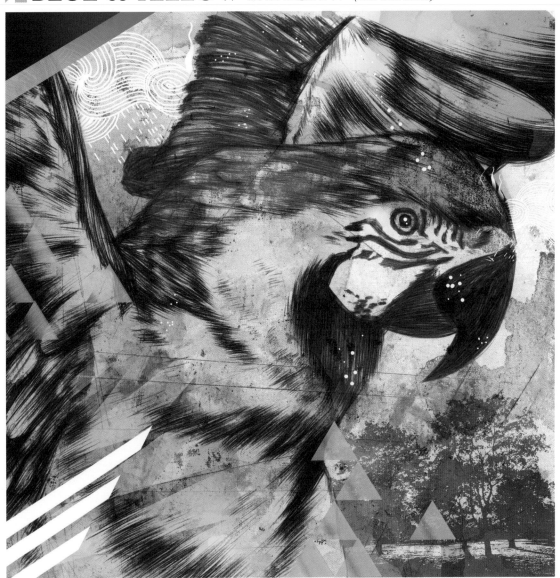

JULIAN GALLASCH.Brazil
www.flickr.com/juliangallasch

CAPYBARA *(Hydrochoerus hydrochaeris)*

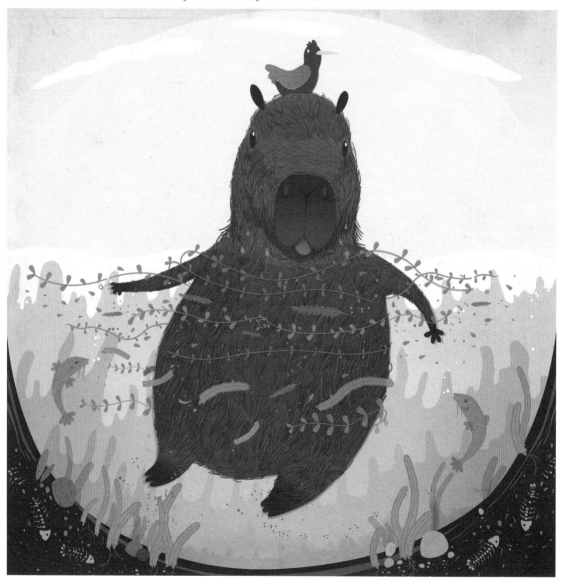

FRAN.Uruguay
www.fran.com.uy

CAREY TURTLE *(Eretmochelys imbricata)*

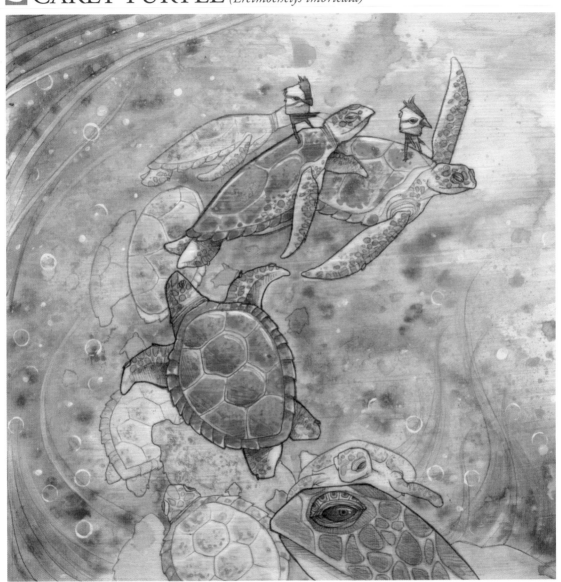

PILAR BERRIO.Colombia
www.pilarberrio.com

COATI *(Nasua nasua)*

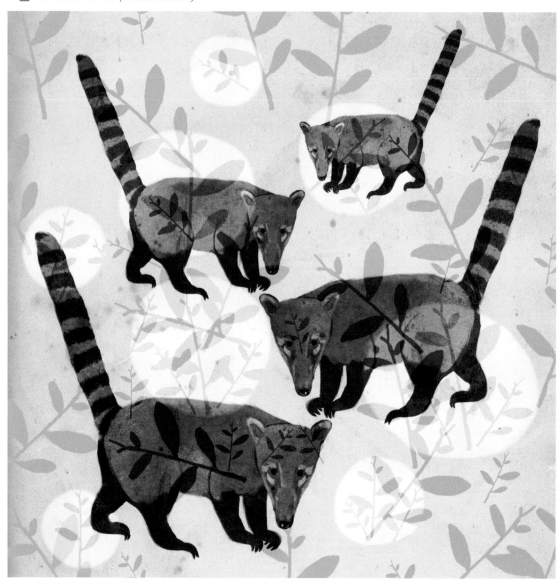

MARIA LUISA ISAZA.Colombia
www.elratondecampo.com

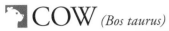 # COW *(Bos taurus)*

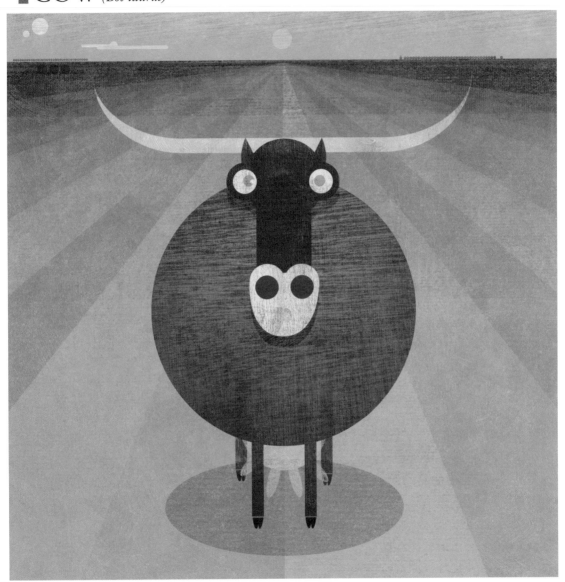

CHRISTIAN MONTENEGRO.Argentina
www.christianmontenegro.com.ar

CRAB *(Pagurus samuelis)*

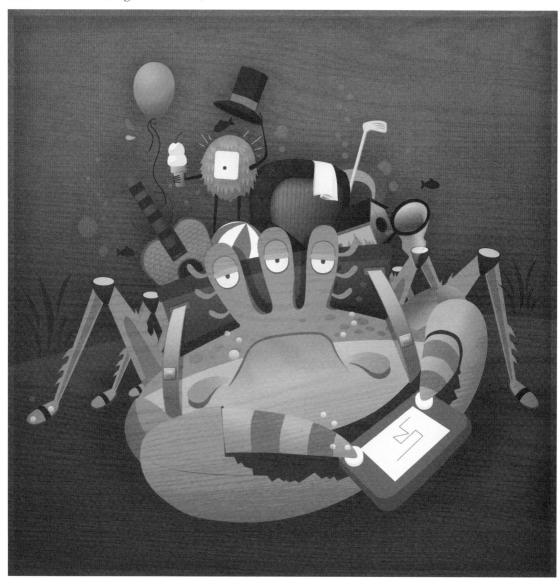

CAMILO BEJARANO.Colombia

www.ph7labs.com

LION TAMARIN *(Leontopithecus chrysomelas)*

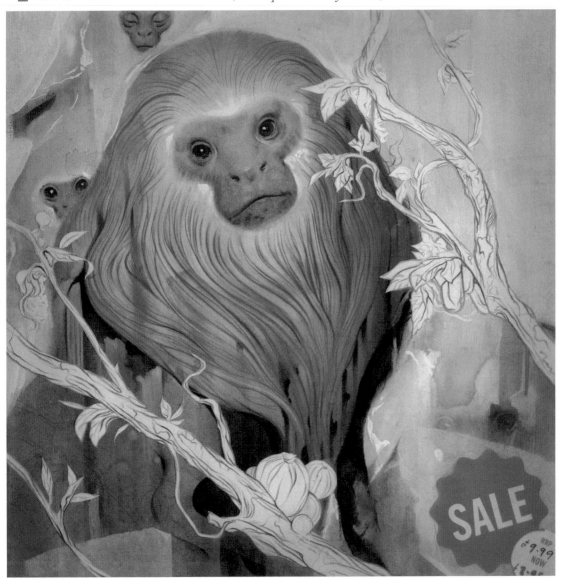

JOAO RUAS.Brazil

www.souvlaki.jp-ar.org

GUACAMAYA *(Ara macao)*

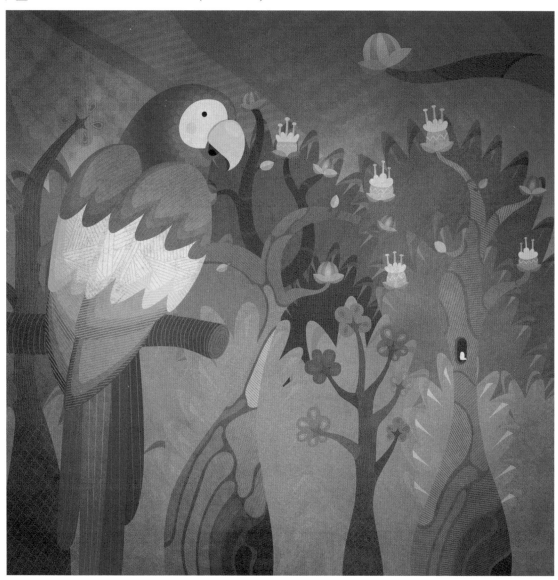

PIKTORAMA.Venezuela
www.piktorama.com

GUANACO *(Lama guanicoe)*

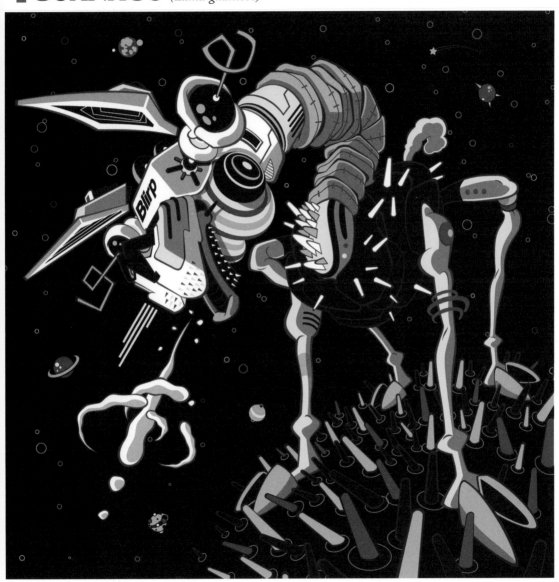

KING PENGUIN *(Aptenodytes patagonicus)*

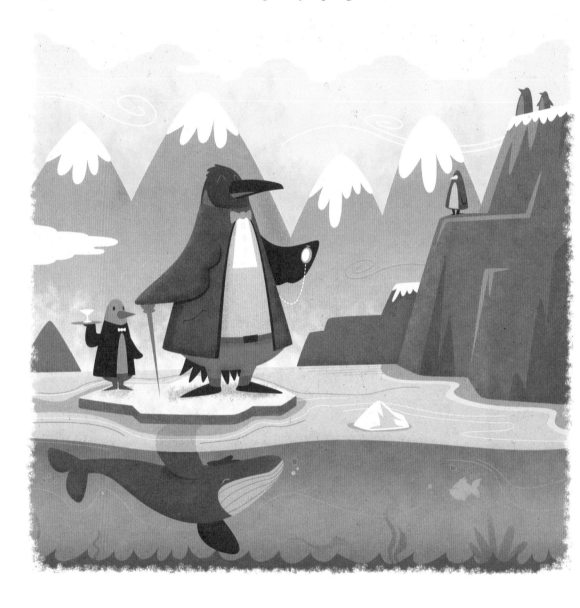

LLAMA *(Lama glama)*

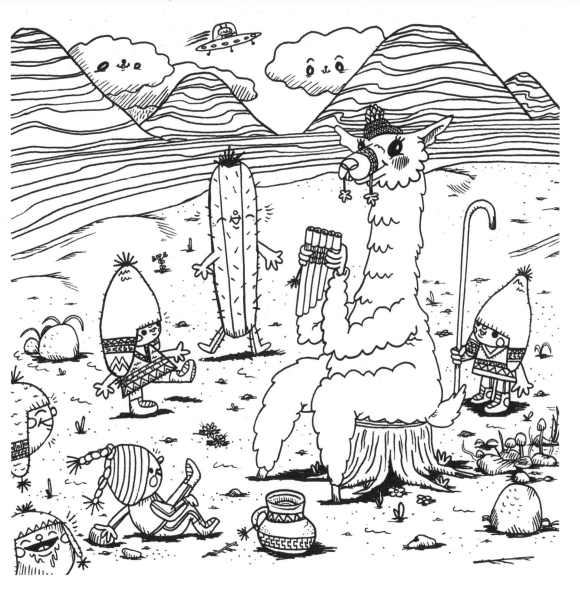

MANED WOLF *(Chrysocyon brachyurus)*

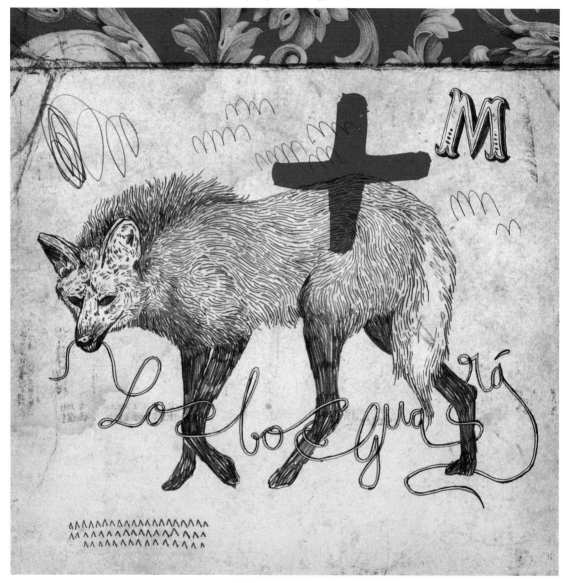

MANTLED HOWLER *(Alouatta palliata)*

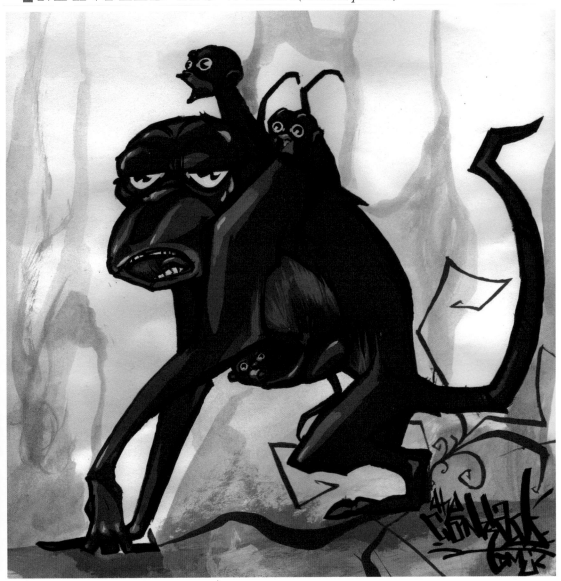

CONRAD.Perú
www.fotolog.com/conradtoys

MONITO DEL MONTE *(Dromiciops gliroides)*

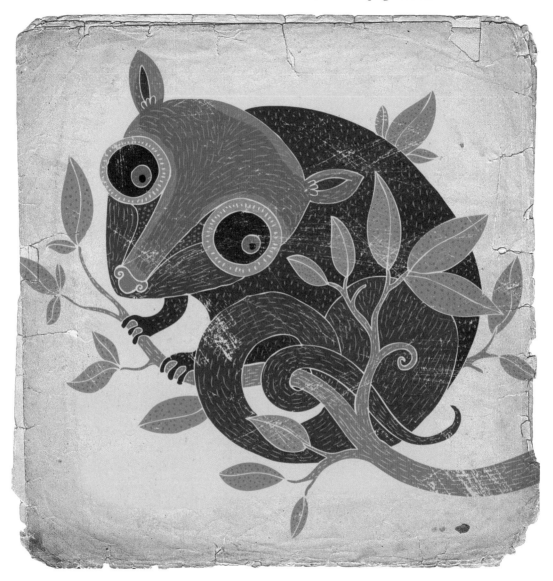

ALBERTO MONTT.Chile
www.dosisdiarias.com

ÑANDU *(Rhea americana)*

ORINOCO CROCODILE *(Crocodylus intermedius)*

IGOR BASTIDAS.Venezuela
www.thegiblife.blogspot.com

PERUVIAN HAIRLESS DOG *(Canis familiares)*

KAPITAN KETCHUP.Perú
www.flickr.com/kapitanketchup

PIRANHA *(Pygocentrus nattereri)*

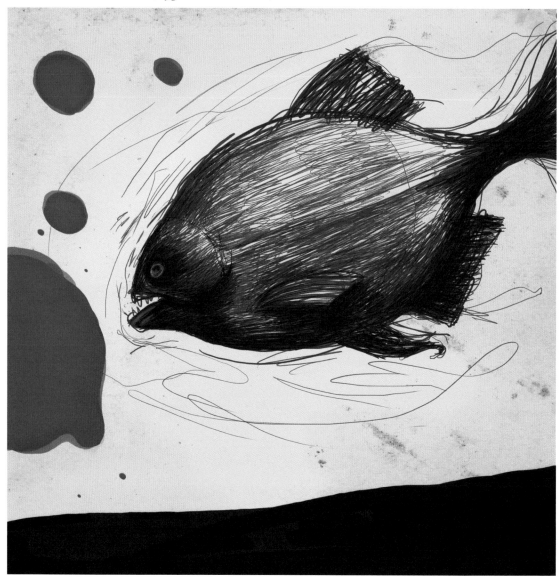

MAURICIO PIERRO.Brazil
www.pierro.com.br

PIRARUCU *(Arapaima gigas)*

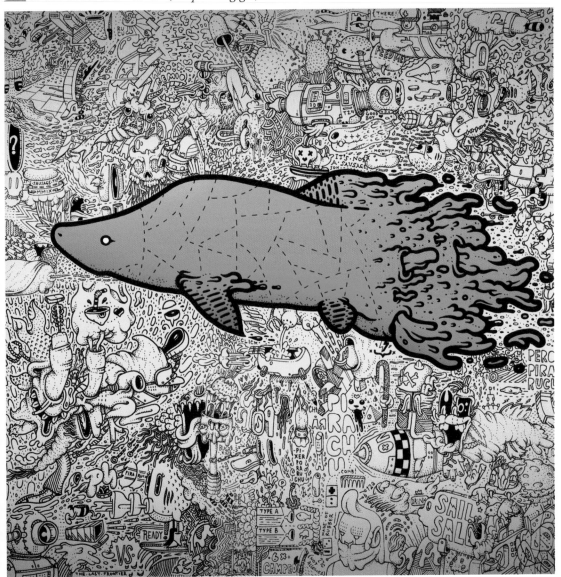

DIEGO MEDINA.Brazil

www.diegomedina.com

PUDU *(Pudú puda)*

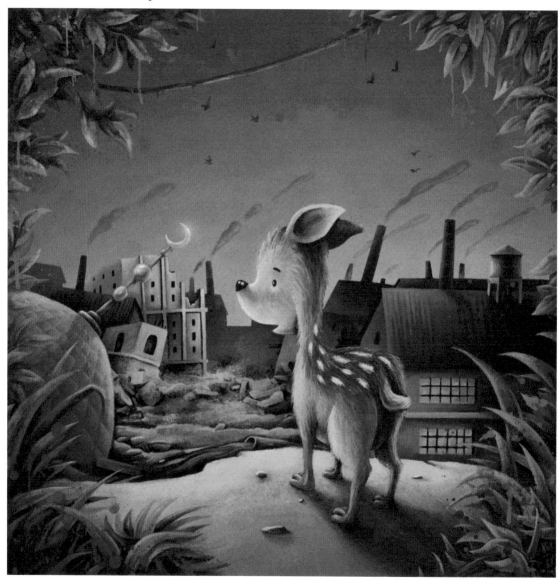

ALEX DUKAL.Argentina
www.circografico.com.ar

SLOTH *(Choloepus hoffmani)*

CHAMARELLI.Brazil
www.flickr.com/lfchamarelli

SPECTACLED BEAR *(Tremarctos ornatus)*

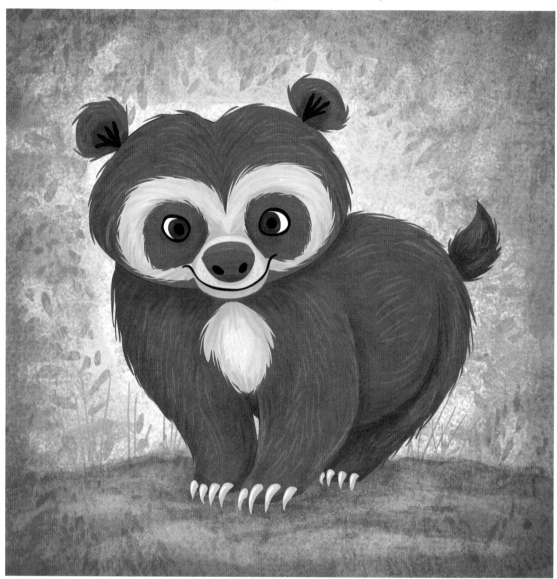

ELISA CHAVARRI.Perú
www.elisachavarri.com

TIGRILLO *(Leopardus tigrinus)*

LORENA ALVAREZ.Colombia
www.lorenaalvarez.com

YACARE OVERO *(Caiman latirostris)*

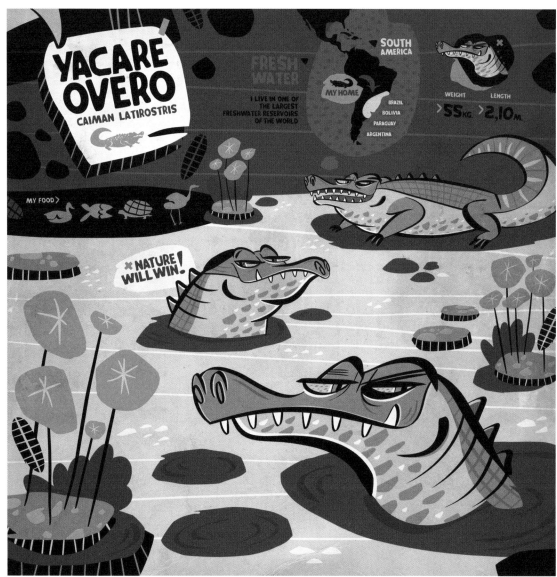

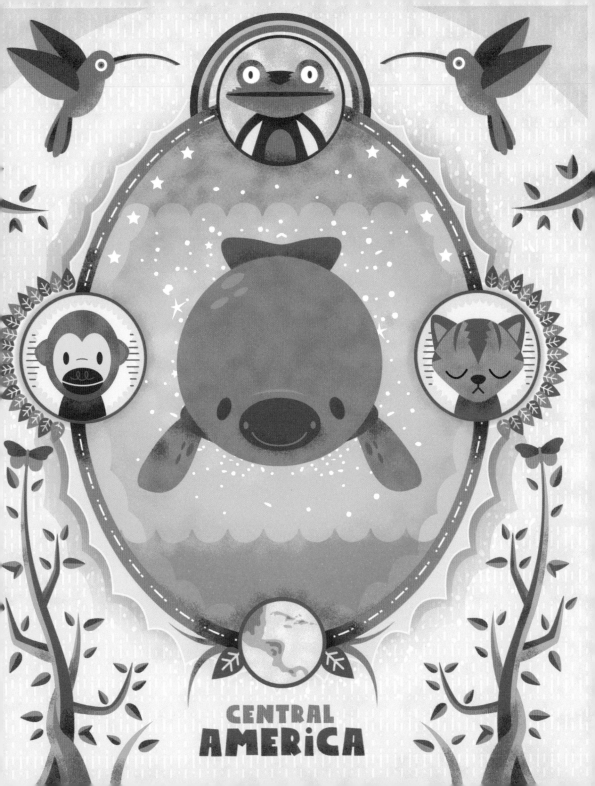

CENTRAL
AMERiCA

BLUE MARLIN *(Makaira nigricans)*

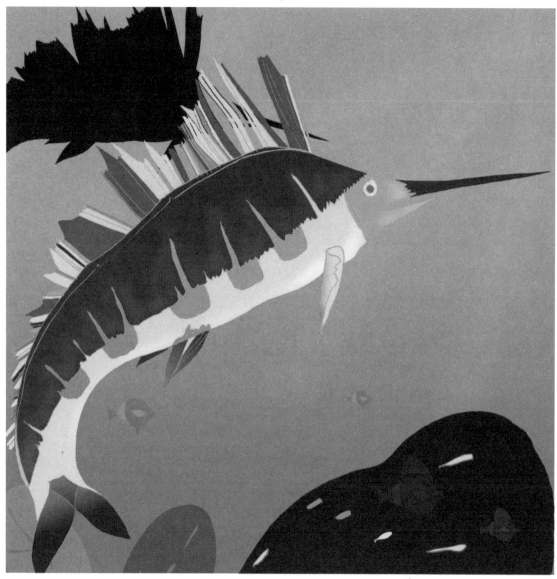

CARIBEAN MANATEE *(Trichechus manatus manatus)*

CHRIS SILVA.Puerto Rico
www.chrissilva.com

NENE GOOSE *(Branta sandvicensis)*

EDWIN USHIRO.Maui

www.mrushiro.com

✖ PINTA ISLAND TORTOISE *(Geochelone nigra abingdoni)*

EDUARDO SARMIENTO.Cuba
www.eduardosarmiento.com

SPIDER MONKEY *(Ateles geoffroyi)*

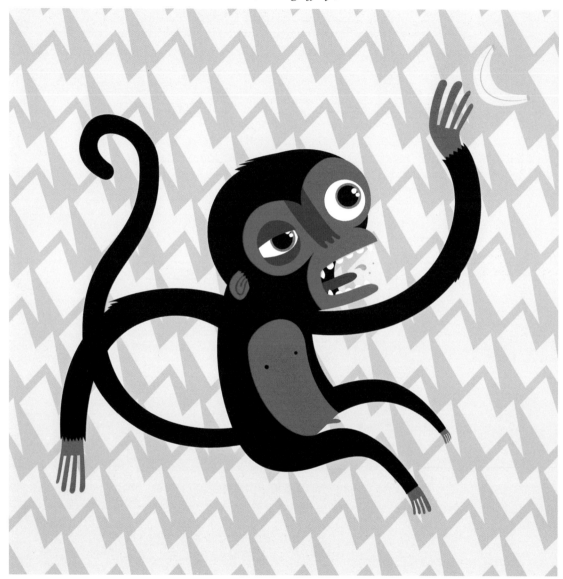

ANDRE GRIBBLE.Guatemala
www.andregribble.blogspot.com

TITI MONKEY *(Callicebus donacophilus)*

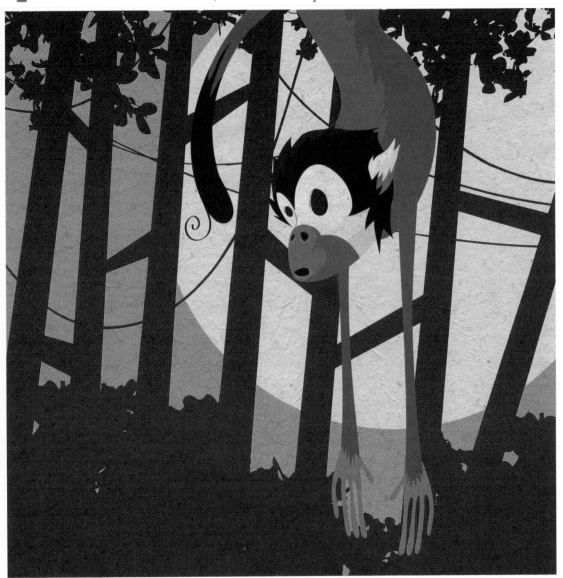

TOUCAN *(Ramphastos sulfuratus)*

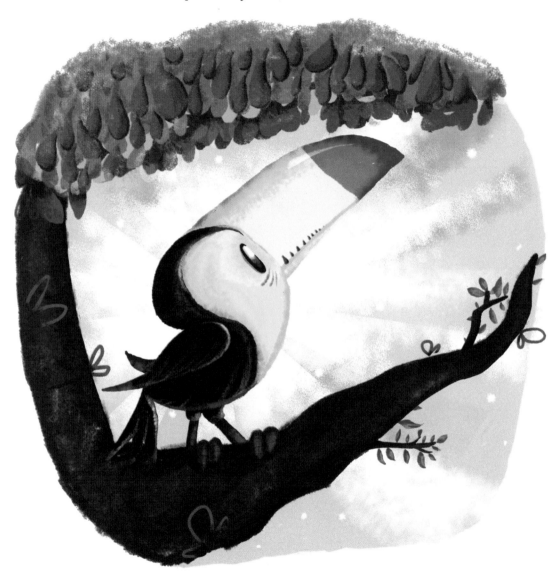

LEO LAMMIE.Panamá
www.leolammie.com

TROGON *(Trogon viridis)*

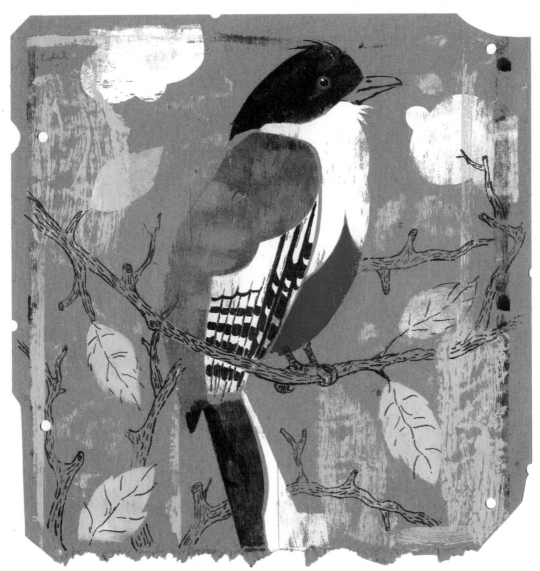

EDEL RODRIGUEZ.Cuba

www.illoz.com/edel

TROPICAL HOUSE GECKO *(Hemidactylus mabouia)*

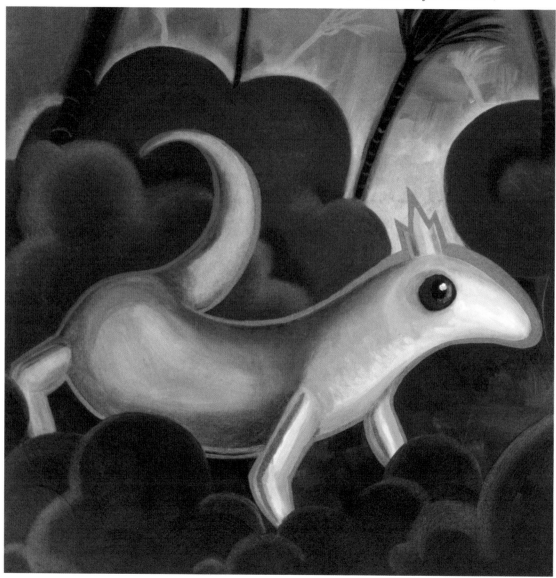

LOU PIMENTEL.Dominican Republic
www.lou-pimentel.com

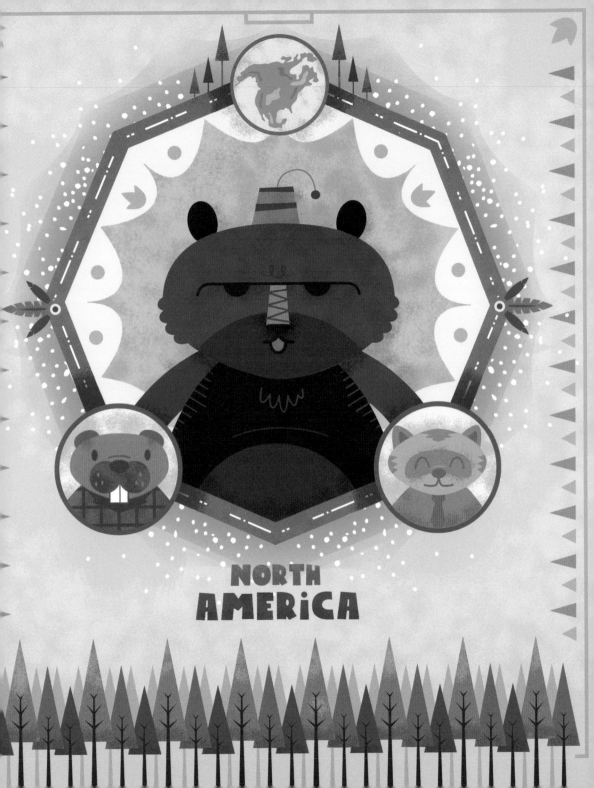

NORTH AMERICA

AMERICAN CROCODILE *(Crocodylus acutus)*

SCOTTY REIFSNYDER.United States

www.seescotty.com

AXOLOTL *(Ambystoma mexicanum)*

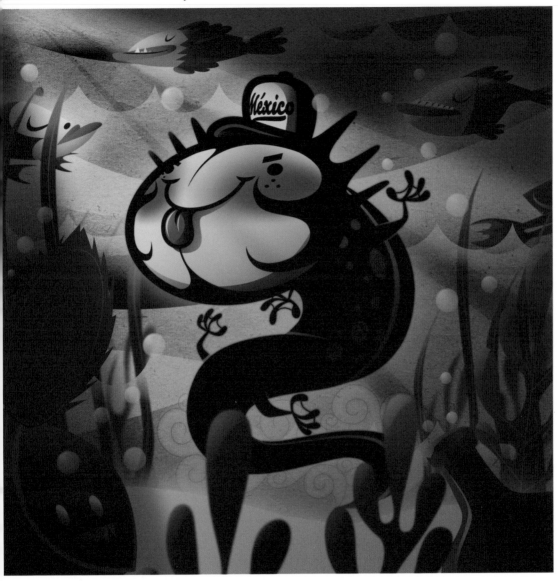

MR. KONE.Mexico
www.mrkone.blogspot.com

BUFFALO *(Bison bison)*

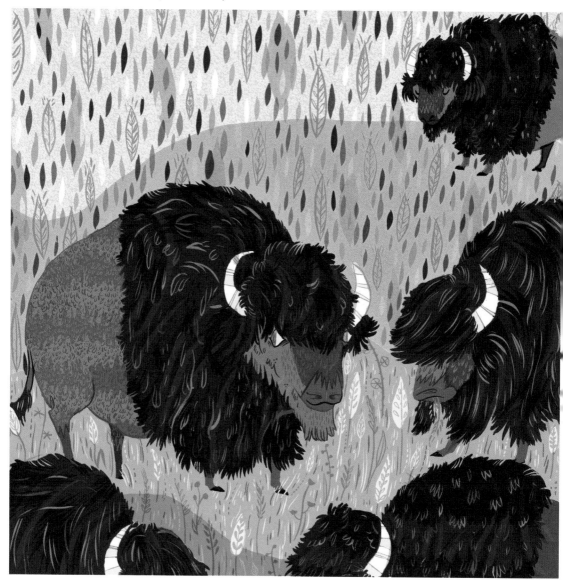

MEG HUNT.United States
www.meghunt.com

BURROWING OWL *(Athene cunicularia)*

EAGLE *(Haliaeetus albicilla)*

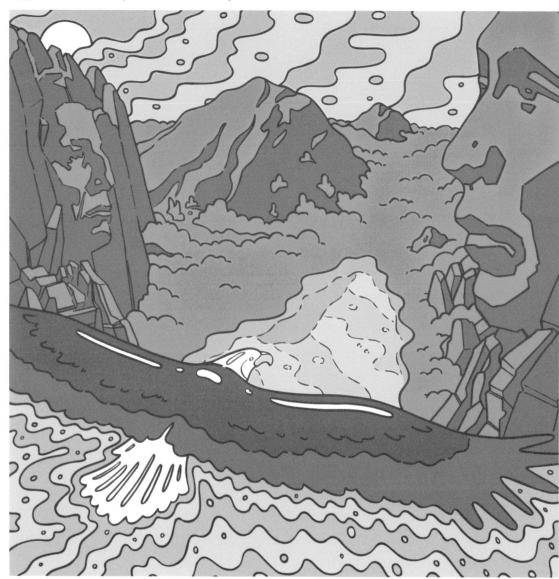

ARBITO.United States

www.arbito.com

HUMMINGBIRD *(Selasphorus rufus)*

JULIE WEST.United States
www.juliewest.com

KANGAROO RAT *(Dipodomys ordii)*

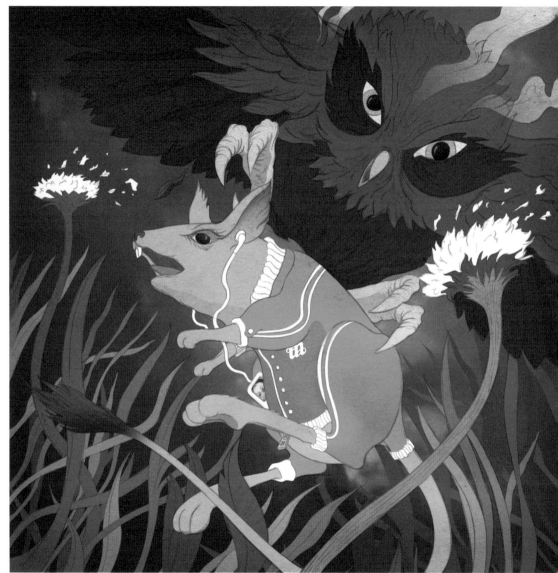

MICHAEL WANDELMAIER.Canada
www.wandelmaier.com

MEXICAN MOUSE OPOSSUM *(Mexican marmosa)*

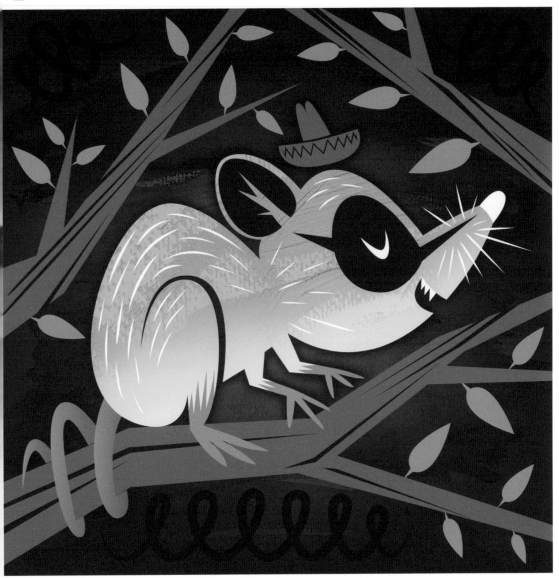

MUSKOX *(Ovibos moschatus)*

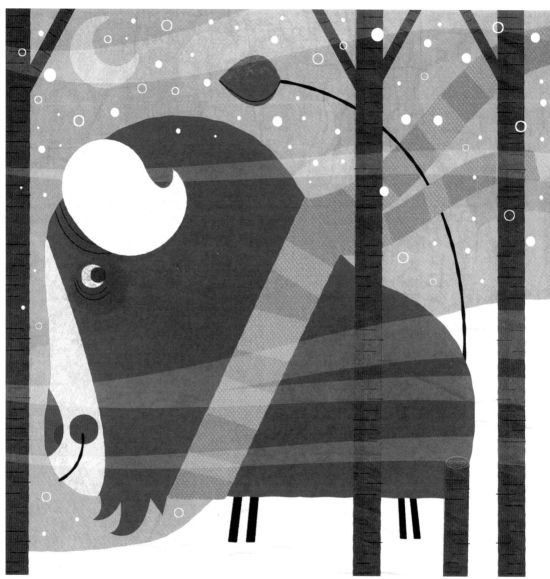

STEVE MACK.Canada
www.illustrationfarm.com

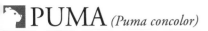

PUMA *(Puma concolor)*

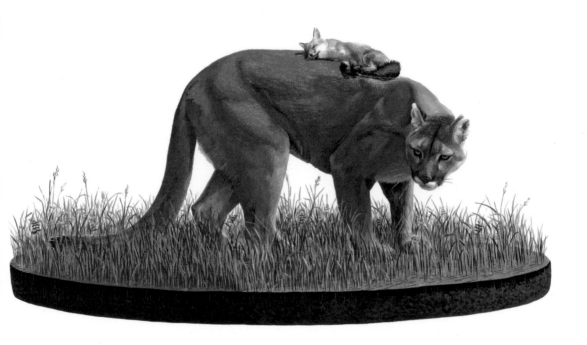

JOSH KEYES.United States
www.joshkeyes.com

OPOSSUM *(Didelphis Virginiana)*

VAN BEATER.United States
www.crappycat.com

ORCA KILLER WHALE *(Orcinus orca)*

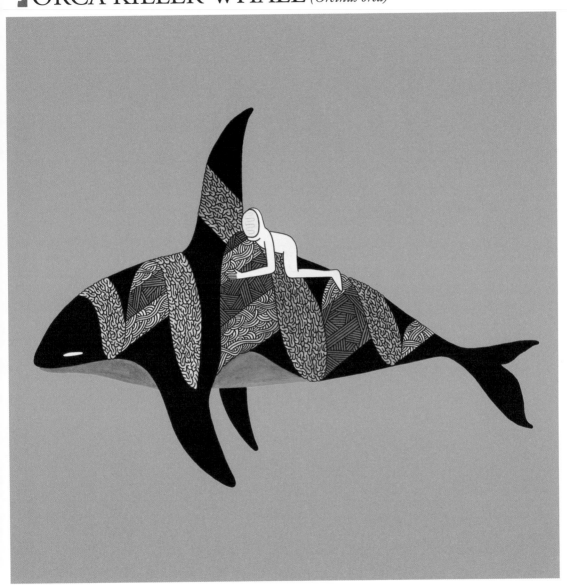

LUKE RAMSEY.Canada
www.islandsfold.com

PIGMY SKUNK *(Spilogale pygmaea)*

DUNDO.Mexico
www.dundoland.com

PORCUPINE *(Erethizon dorsatum)*

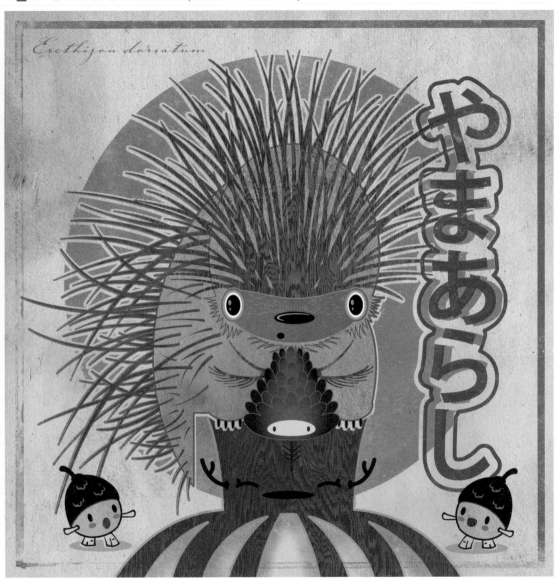

Erethizon dorsatum

やまあらし

64 COLORS.United States

www.64colors.com

PRAIRIE DOG *(Cynomys)*

APAK.United States
www.apakstudio.com

PRONGHORN *(Antilocapra americana)*

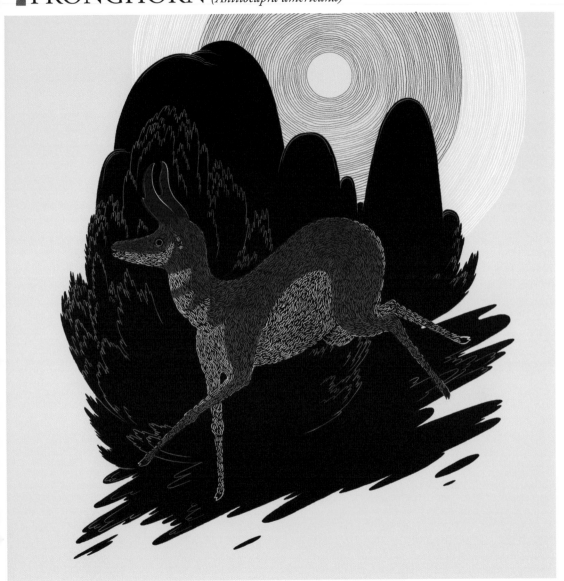

MICAH LINDBERG.United States

www.micahlidberg.com

QUAIL *(Coturnix coturnix)*

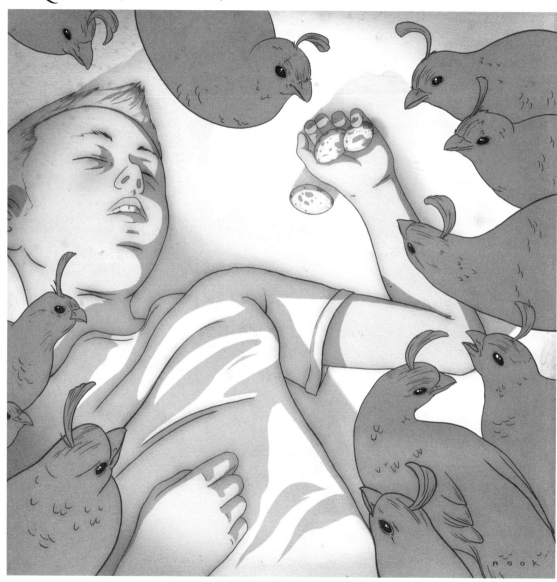

NOOK.United States
www.nook.carbonmade.com

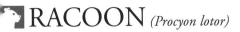
RACOON *(Procyon lotor)*

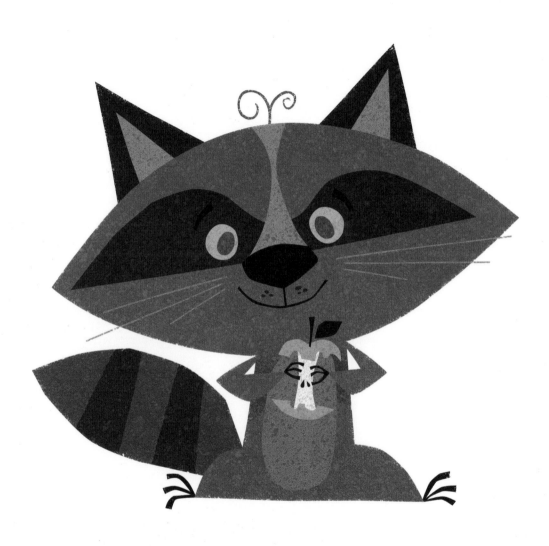

JOHNY YANOK.United States
www.johnnyyanok.com

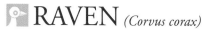

RAVEN *(Corvus corax)*

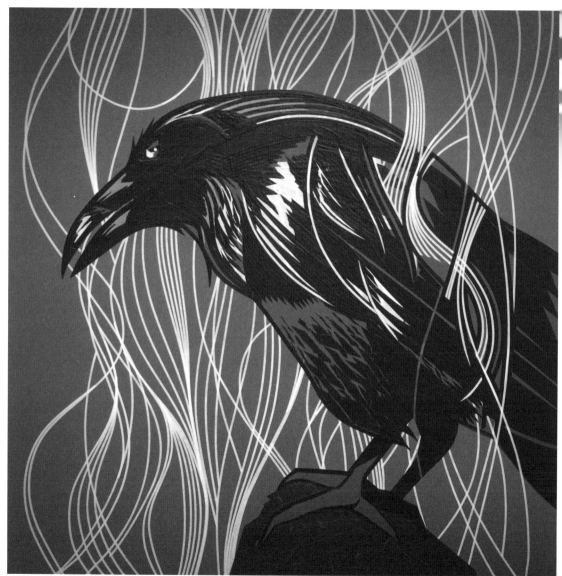

CHRIS HOSMER.United States
www.chworkshop.com

ROADRUNNER *(Geococcyx californianus)*

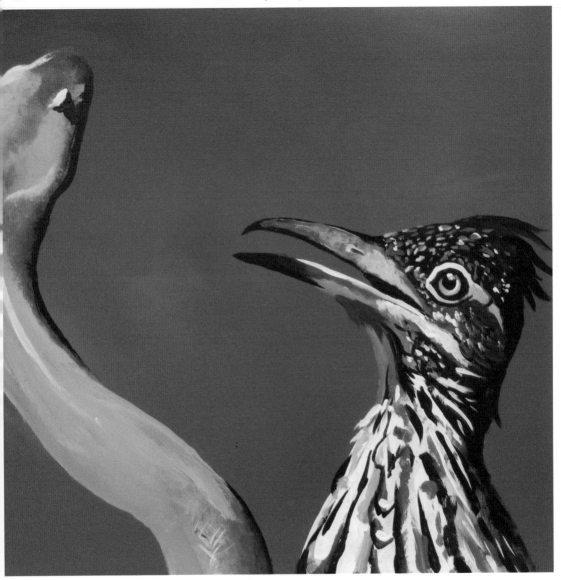

MINCING MOCKING BIRD.United States
www.mincingmockingbird.com

SOCKEYE SALMON *(Oncorhynchus nerka)*

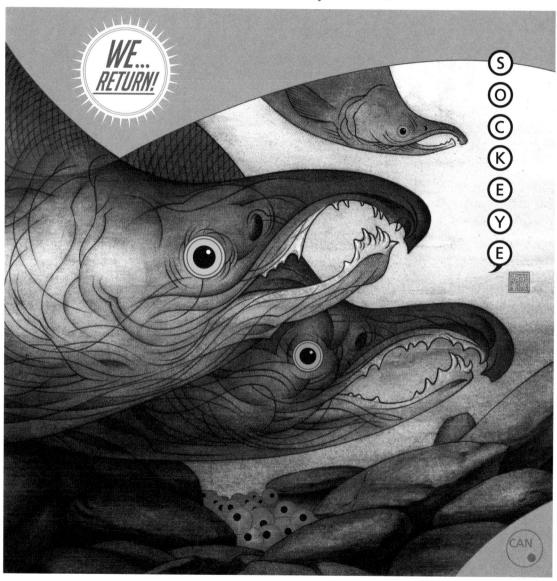

ED KWONG.Canada

www.edkwong.com

TANAGER *(Thraupis episcopus)*

FRIENDS WITH YOU.United States
www.friendswithyou.com

TECOLOTE *(Strix occidentalis lucida)*

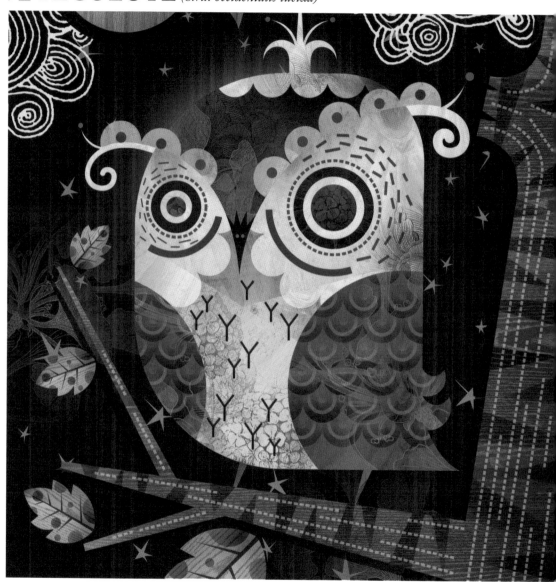

ALBERTO CERRITEÑO.Mexico
www.albertocerriteno.com

VAQUITA MARINA *(Phocoena sinus)*

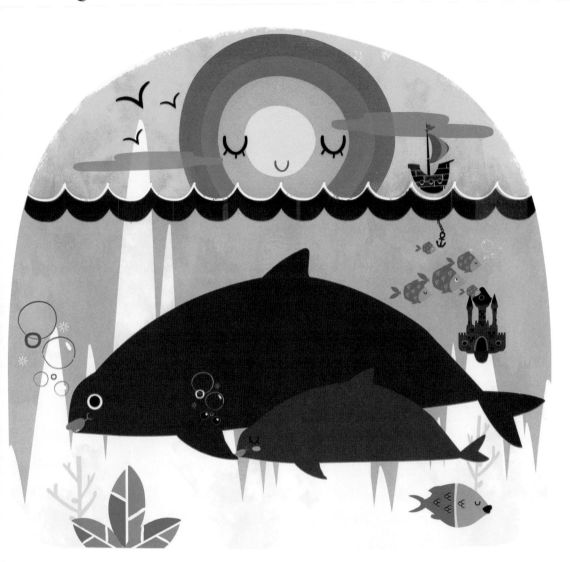

VULTURE *(Coragyps atratus)*

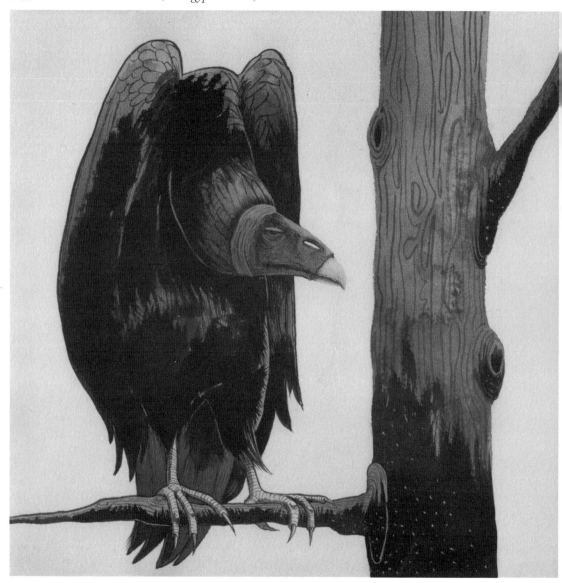

KEN GARDUNO.United States

www.kengarduno.com

WALRUS *(Odobenus rosmarus)*

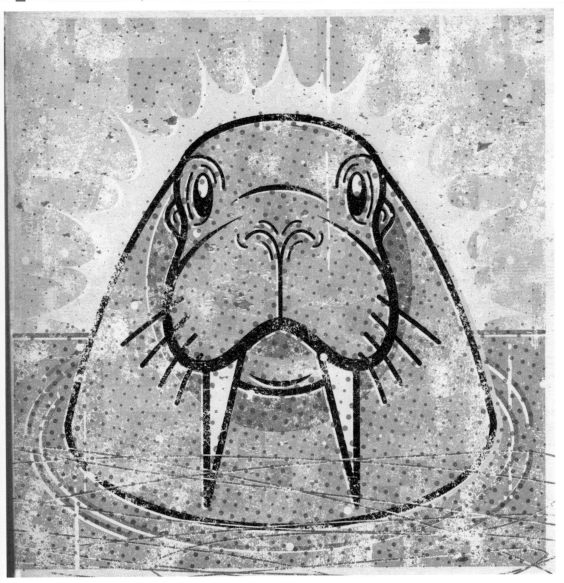

ALEXEI VELLA.Canada
www.alexeivella.com

WOOD TURTLE *(Glyptemys insculpta)*

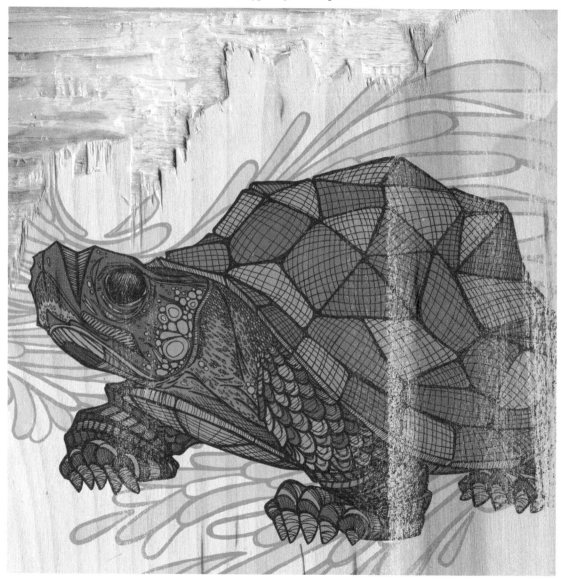

JOHN VOGL.United States

www.thebungaloo.com

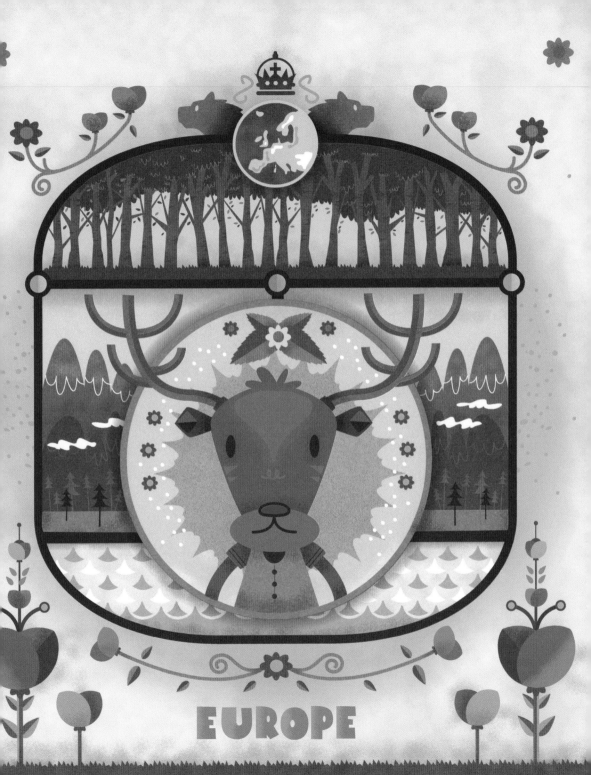

EUROPE

ADDER *(Vipera berus)*

HUMAN EMPIRE.Germany
www.humanempire.com

ARCTIC FOX *(Aquila verreauxii)*

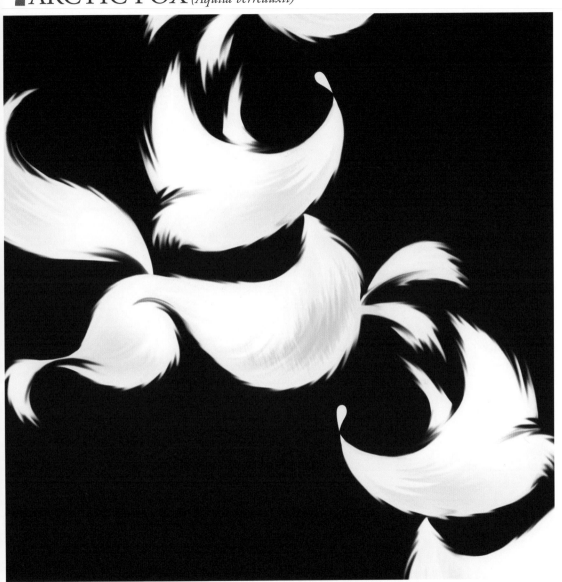

MADSBERG.Norway

www.madsberg.dk

BADGER *(Meles meles)*

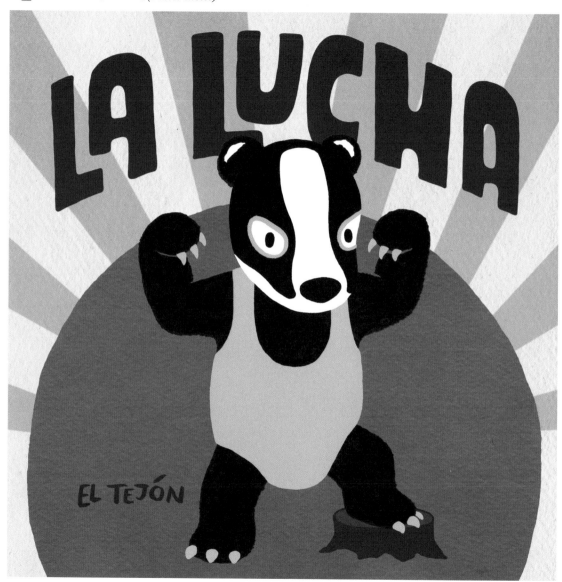

JUJU´S DELIVERY.Germany
www.jujus-delivery.com

BARN OWL *(Tyto alba)*

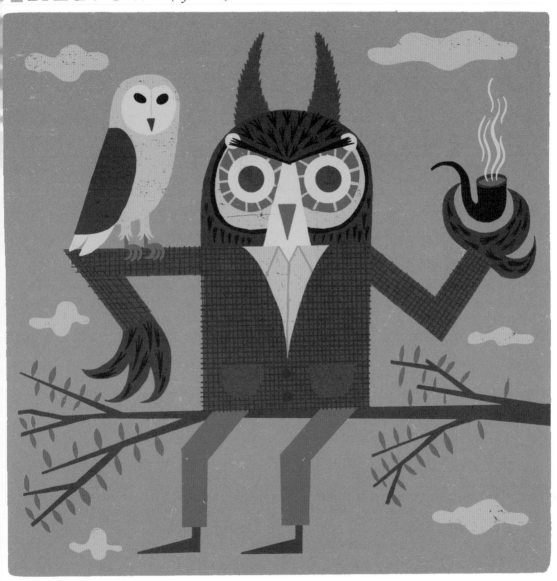

BEN NEWMAN.England
www.bennewman.co.uk

BLACK-WINGED STILT *(Himantopus himantopus)*

COLLIN VAN DER SLUIJS.Netherlands
www.collinvandersluijs.com

BOARHOUND *(Canis lupus familiaris)*

PEACHBEACH.Germany
www.peachbeach.de

BROWN BEAR *(Ursus arctos)*

HELLO FREAKS.France
www.hellofreaks.com

BROWN RAT *(Rattus norvegicus)*

STEVE SIMPSON.Ireland
www.stevesimpson.com

CHAMOIS *(Rupicapra rupicapra)*

COCKEREL *(Gallus gallus)*

KAT LEUZINGER.Switzerland
www.katleuzinger.com

COYPU *(Myocastor coypus)*

EASY HEY.France
www.delkographik.com

CRAYFISH *(Astacus leptodactylus)*

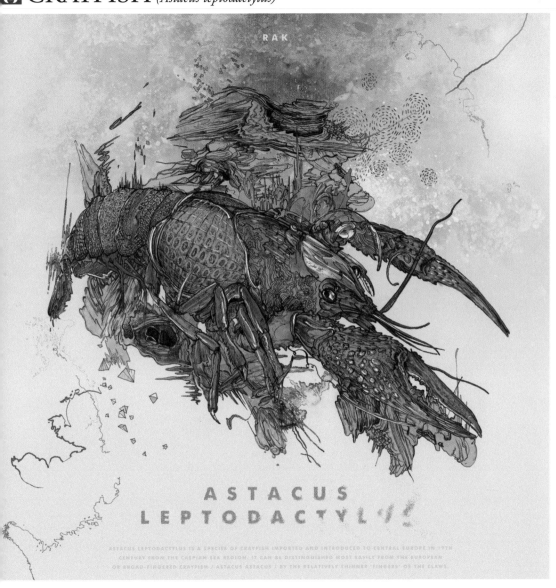

RAK

ASTACUS
LEPTODACTYLUS

ASTACUS LEPTODACTYLUS IS A SPECIES OF CRAYFISH IMPORTED AND INTRODUCED TO CENTRAL EUROPE IN 19TH
CENTURY FROM THE CASPIAN SEA REGION. IT CAN BE DISTINGUISHED MOST EASILY FROM THE EUROPEAN
OR BROAD-FINGERED CRAYFISH / ASTACUS ASTACUS / BY THE RELATIVELY THINNER 'FINGERS' OF THE CLAWS.

STUDIO KXX.Poland
www.studiokxx.com

CUTTLE FISH *(Sepia officinalis)*

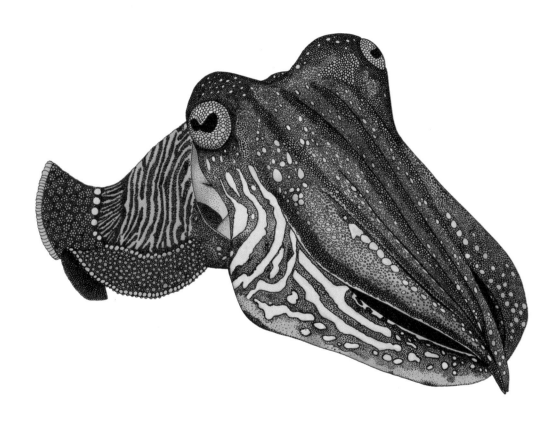

CLAIRE SCULLY.United Kingdom
www.thequietrevolution.co.uk

DEER *(Dama dama)*

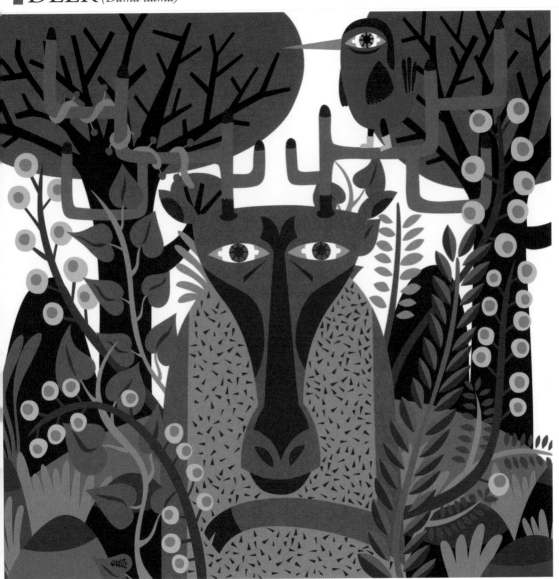

DONKEY *(Equus africanus asinus)*

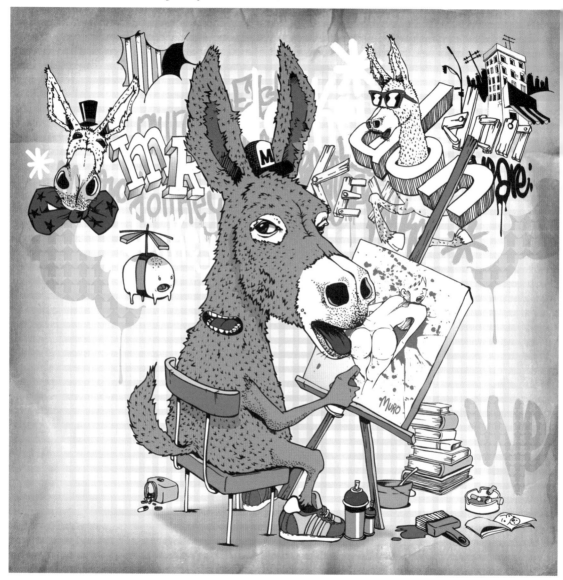

DORMOUSE *(Muscardinidae)*

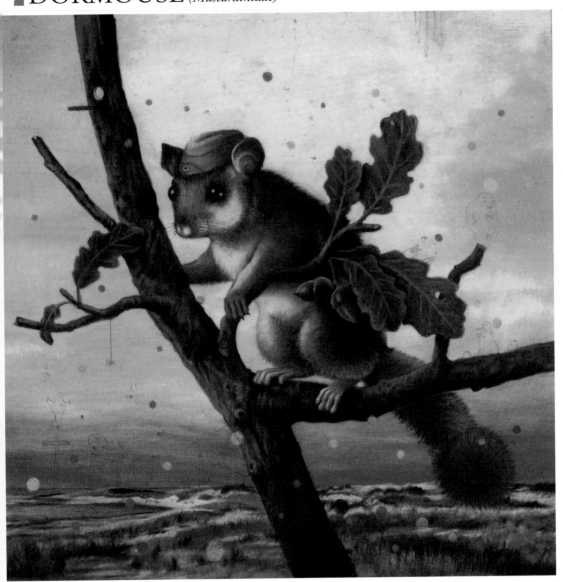

HEIKO MULLER.Germany
www.heikomueller.de

DRAGONFLY *(Libellula depressa)*

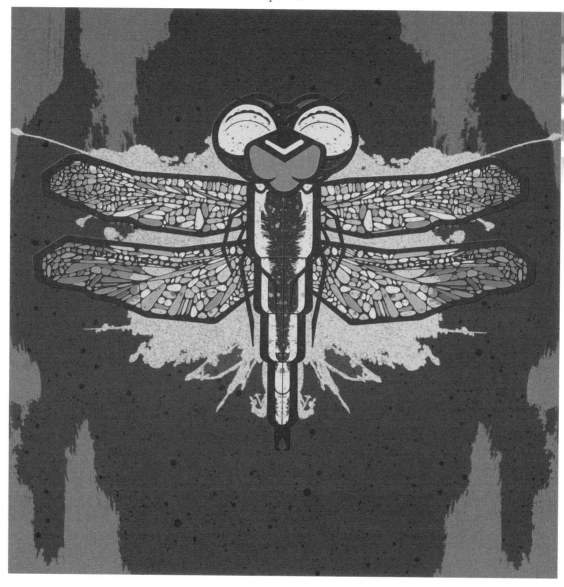

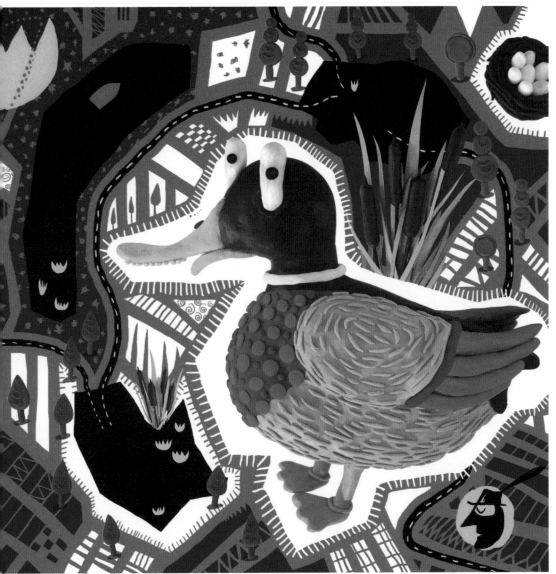

RUDPUNK.Ukraine
www.rudpunk.com

EUROPEAN BEAVER *(Castor fiber)*

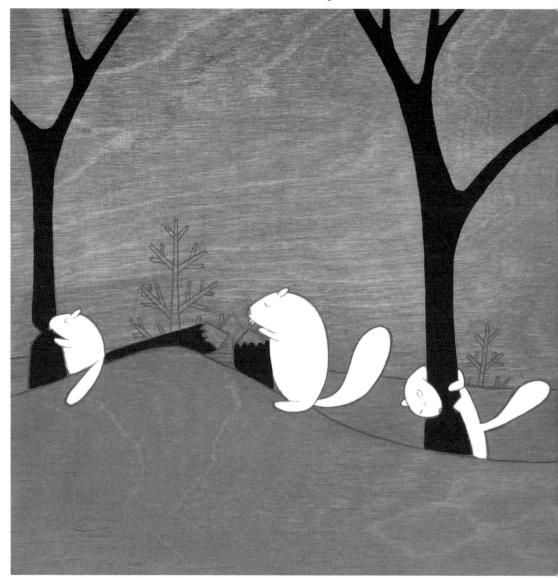

KRISTIANA PARN.Estonia
www.kristianaparn.com

ALEKSANDER KOSTENKO.Russia
www.behance.net/Kostenko

FALCON *(Falco tinnunculus)*

MIKKO WALLAMIES.Finland

www.mwillustration.blogspot.com

FIRE SALAMANDER *(Salamandra salamandra)*

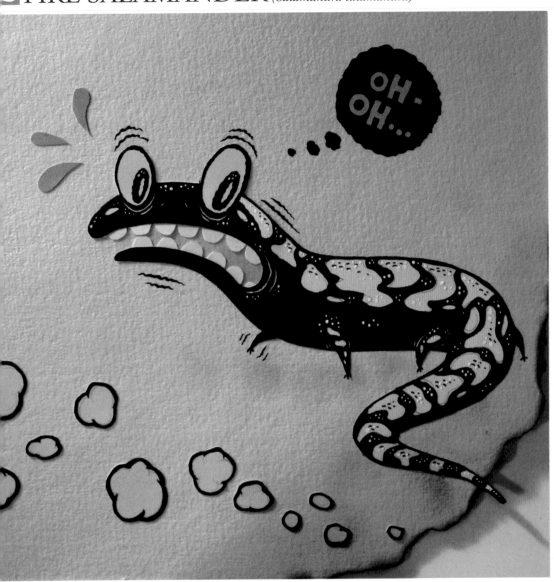

MICHAEL HACKER.Austria
www.michaelhacker.at

FLAMINGO *(Phoenicopterus roseus)*

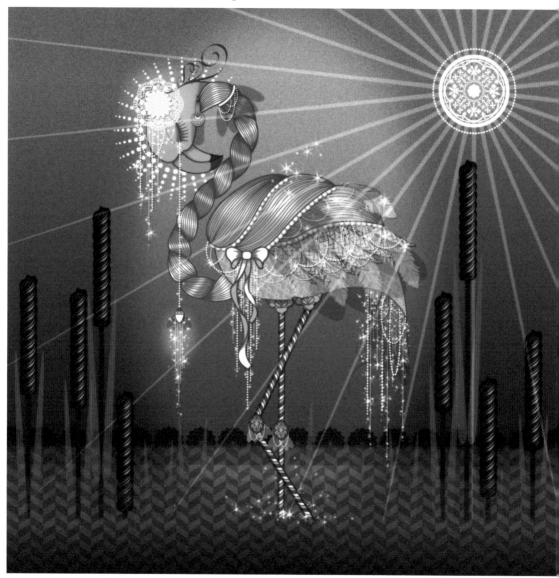

KORALIE.France
www.koralie.net

FLYING SQUIRREL *(Pteromyini)*

GORDEI.Russia
gordei.livejournal.com

GARDEN DORMOUSE *(Eliomys quercinus)*

ANA GALVAN.Spain
www.anagalvan.com

GINETA *(Genetta genetta)*

GREAT AUK *(Pinguinus impennis)*

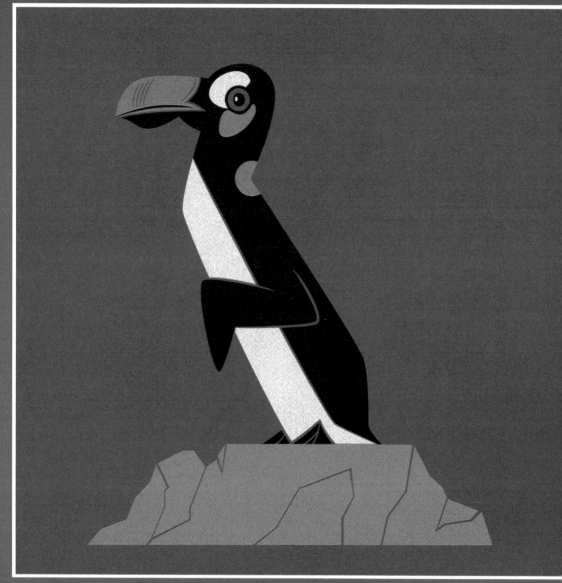

NISHANT CHOKSI.United Kingdom
www.nishantchoksi.com

GREAT BUSTARD *(Otis tarda)*

PETRA STEFANKOVA.Slovakia

www.petrastefankova.com

GREY HERON *(Ardea cinerea)*

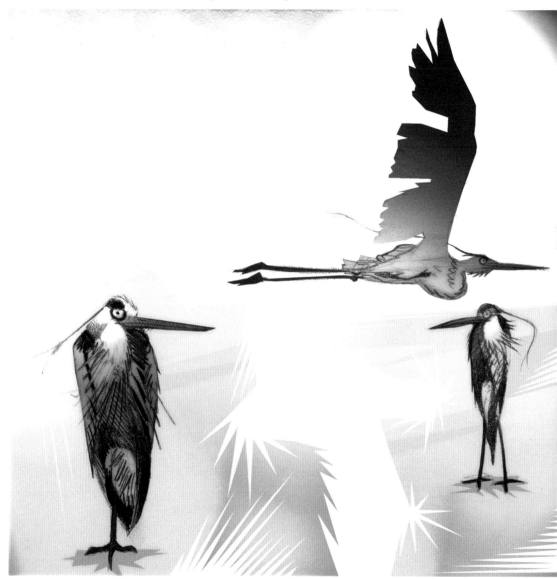

LENNARD SCHUURMANS.Netherlands

www.v-i-a-v-i-a.nl

HARE *(Lepus europaeus)*

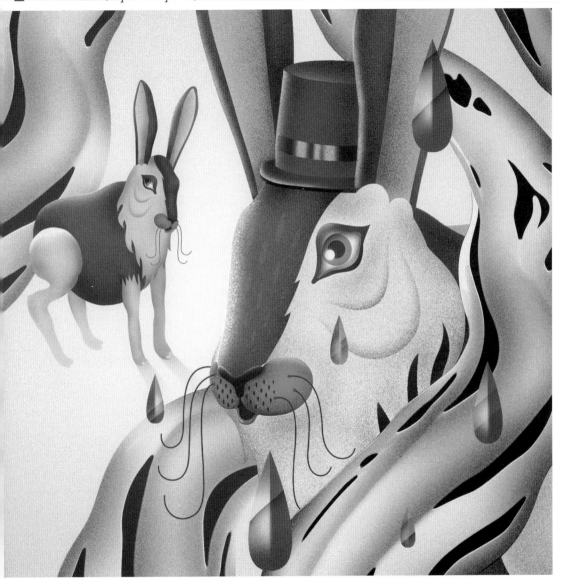

VILLE SAVIMAA.Finland

www.villesavimaa.com

HEDGEHOG *(Erinaceus europaeus)*

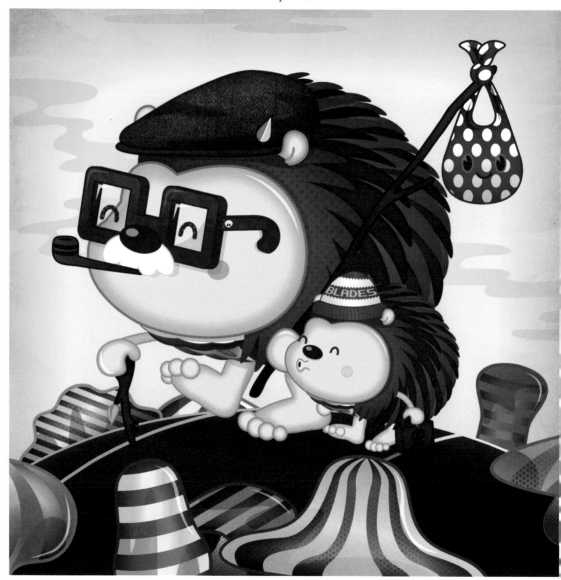

HERMANN'S TORTOISE *(Testudo hermanni)*

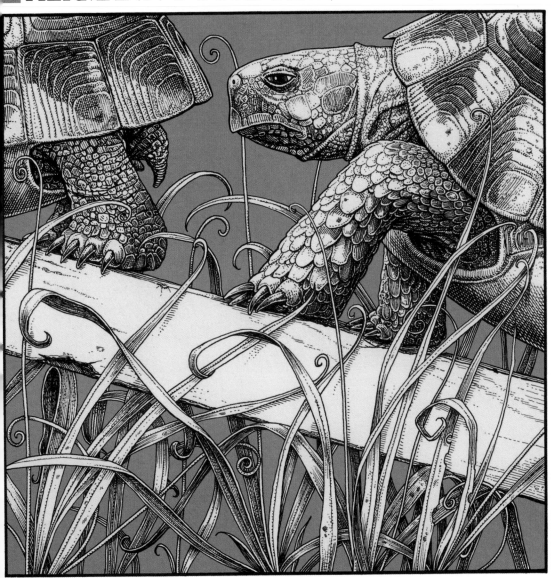

TOMI SLAVTOMIC.Croatia
www.tomislavtomic.com

HIGHLAND COW *(Bos Taurus)*

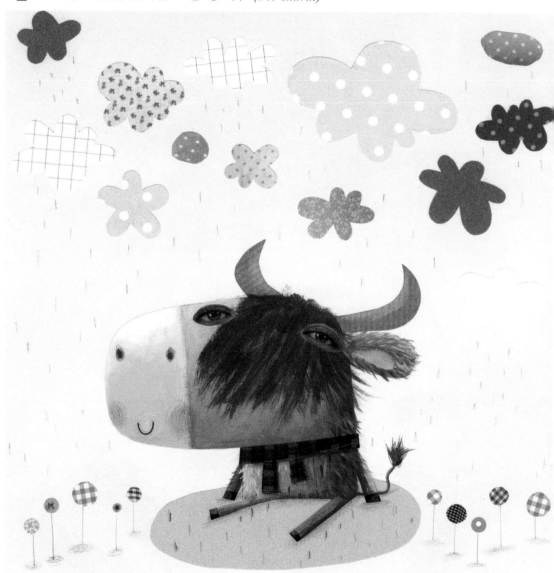

JULIE FLETCHER.Scotland
www.juliefletcher.co.uk

IBERIAN LYNX *(Lynx pardinus)*

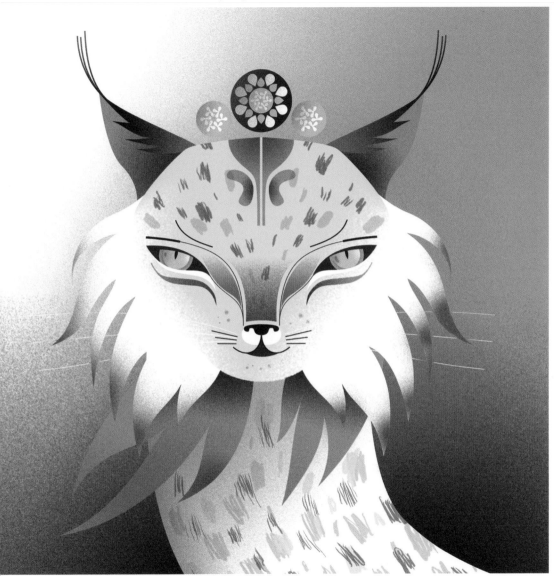

MALOTA.Spain
www.malotaprojects.com

IBEX *(Capra ibex)*

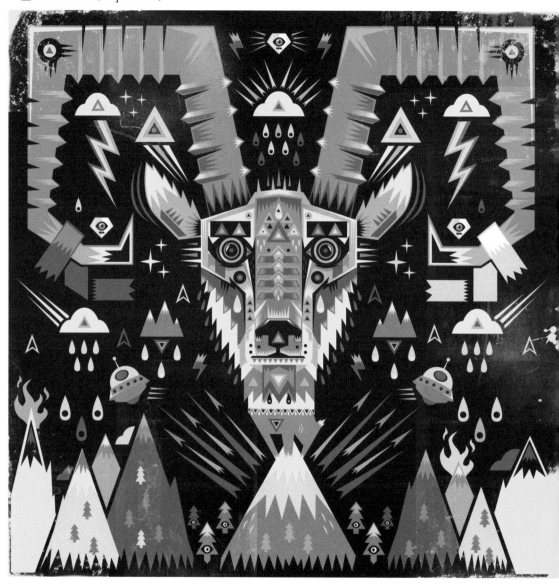

NIARK1.France
www.niark1.com

ICELANDIC HORSE *(Equus caballus)*

GEOFFREY SKYWALKER.Iceland
www.flickr.com/geoffreyskywalker

KINGFISHER *(Alcedo atthis)*

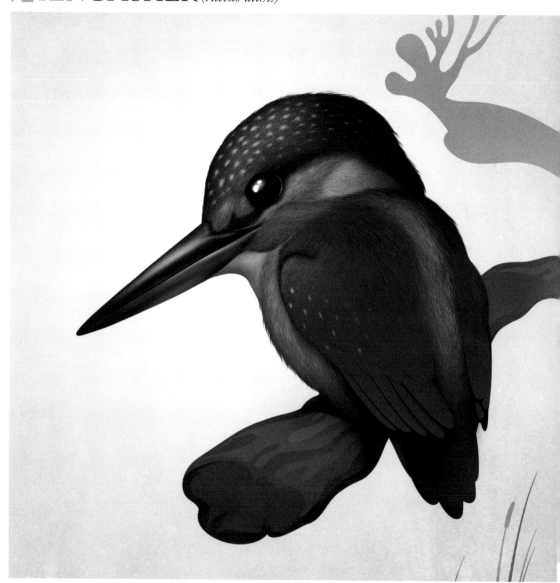

MARK VERHAAGEN.Netherlands
www.markverhaagen.com

KRI-KRI *(Capra aegagrus creticus)*

LADYBUG *(Coccinella septempunctata)*

ONESIDEZERO.United Kingdom
www.onesidezero.co.uk

MARMOT *(Capra aegagrus creticus)*

MICROBAT *(Microchiroptera)*

PAPRIKO.Switzerland

www.papriko-inc.com

MINK *(Mustela lutreola)*

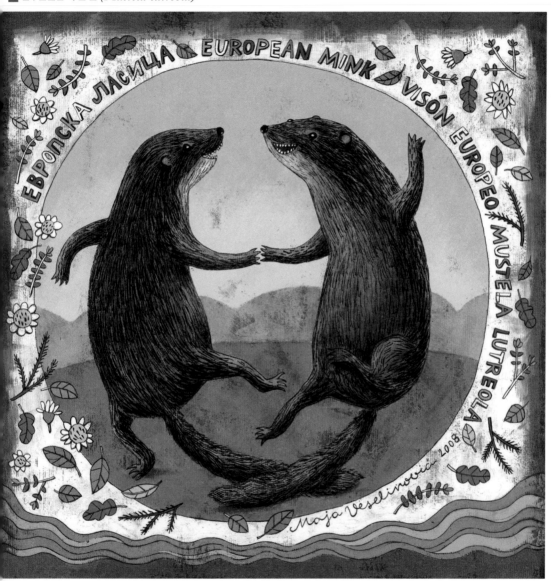

MAJA VESELINOVIC.Serbia
ww.majaveselinovic.com

MOLE *(Talpa europaea)*

BURO DESTRUCT.Switzerland

www.burodestruct.net

MOOSE *(Alces alces)*

SANDRA JUTO.Sweeden
www.sandrajuto.com

MOTH *(Tineola bisselliella)*

LINDE DESIGN.Germany
www.lindedesign.de

MOUFLON *(Ovis orientalis orientalis)*

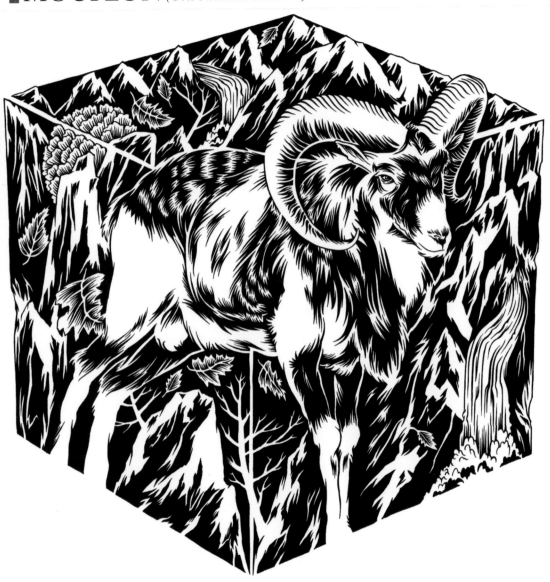

JORN KASPUHL.Germany
www.kaspuhl.com

MUSKRAT *(Ondatra zibethicus)*

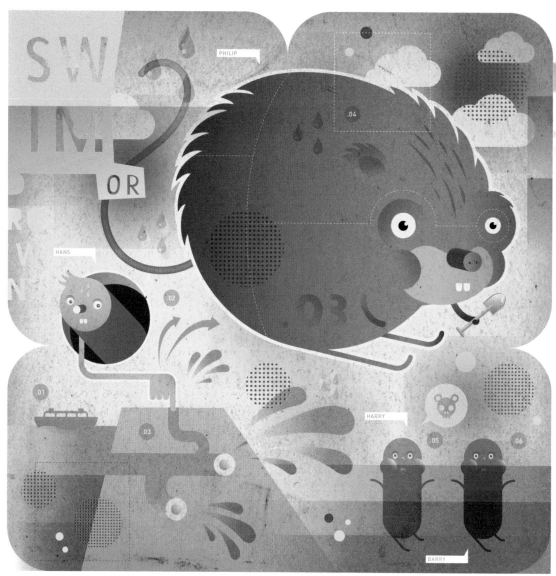

NORTHERN BALD IBIS *(Geronticus eremita)*

PUÑO.Spain
www.kokekoko.com

OCTOPUS *(Octopus vulgaris)*

 OTTER *(Lutra lutra)*

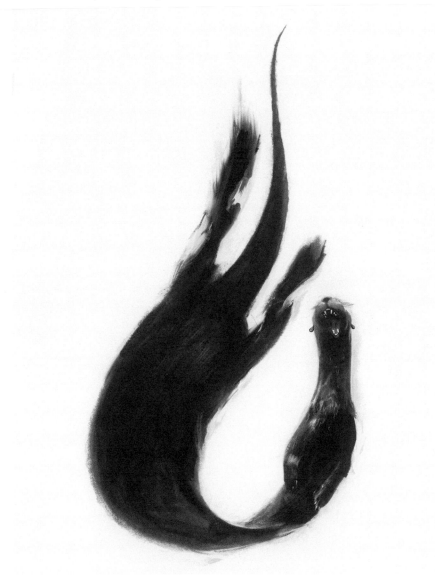

FONS SCHIEDON.Netherlands
www.fonztv.nl

PERCHFISH *(Perca fluviatilis)*

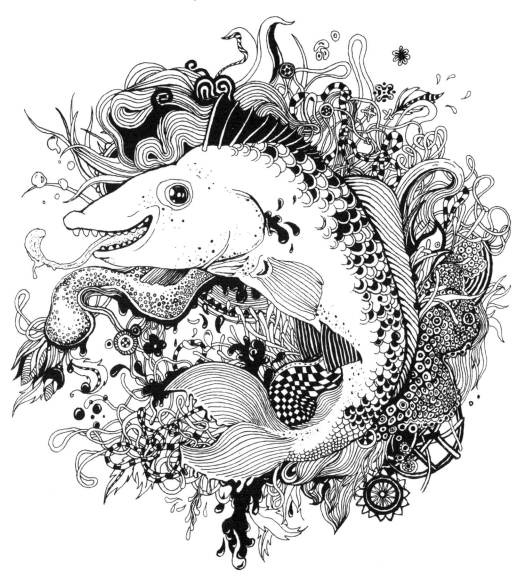

BOMBOLAND.Italy
www.bomboland.com

 PIG *(Danish Landrace)*

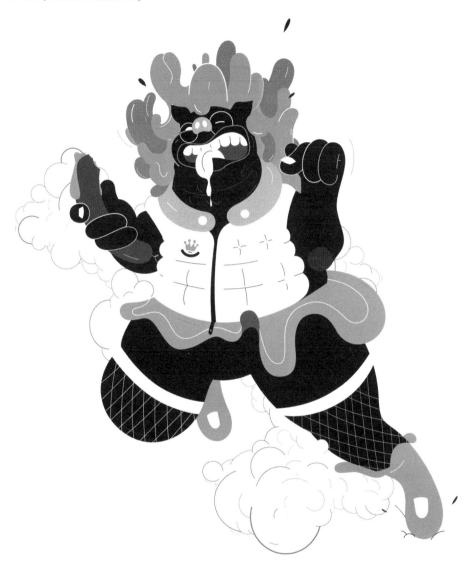

PIGMY SHREW *(Sorex minutus)*

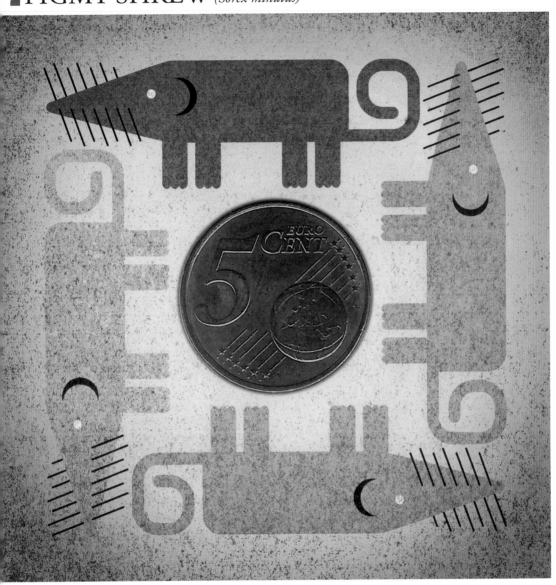

PINE MARTEN *(Martes martes)*

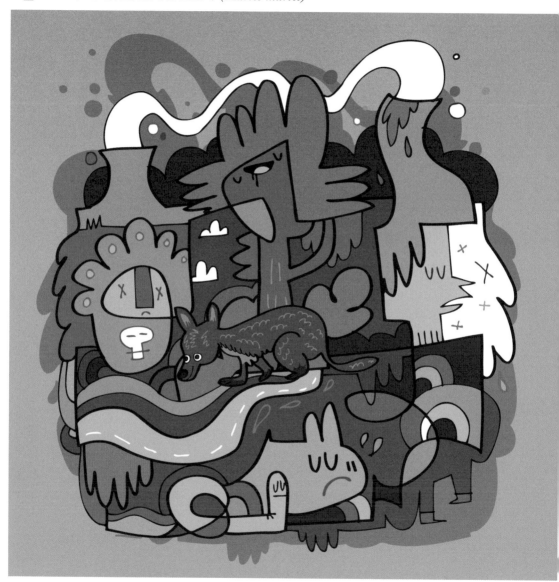

JON BURGERMAN. United Kingdom
www.jonburgerman.com

POLAR BEAR *(Sorex minutus)*

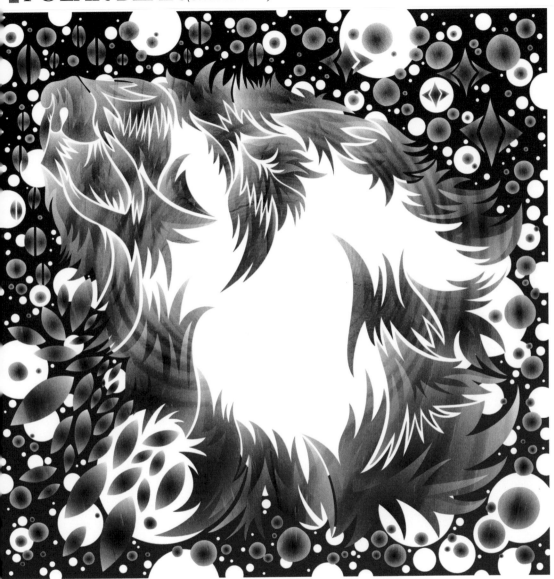

POLECAT *(Mustela putorius)*

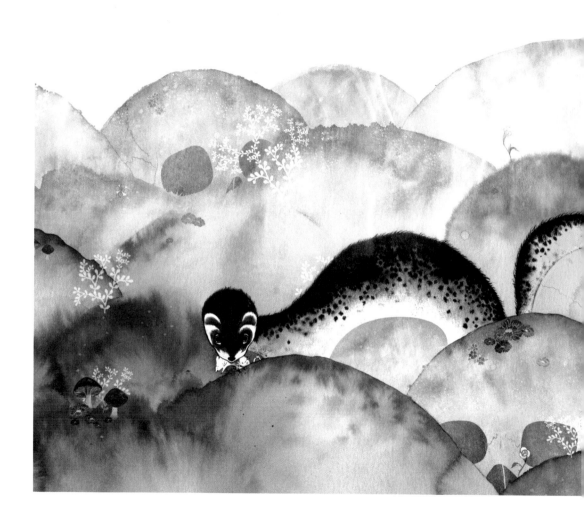

RAQUELISSIMA.Spain
www.raquelissima.com

PORCUPINEFISH *(Diodon nicthemerus)*

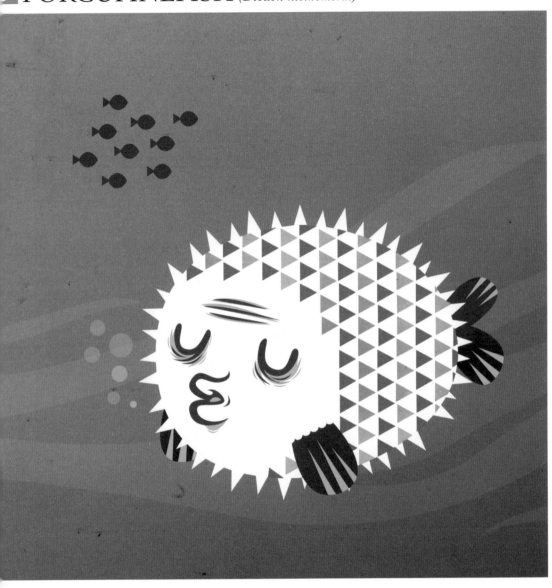

TOUGUI.France
www.tougui.fr

PORTUGUESE WATER DOG *(Cão d'Água)*

PAULO ARRAIANO.Portugal

www.pauloarraiano.com

PUFFINS *(Fratercula arctica)*

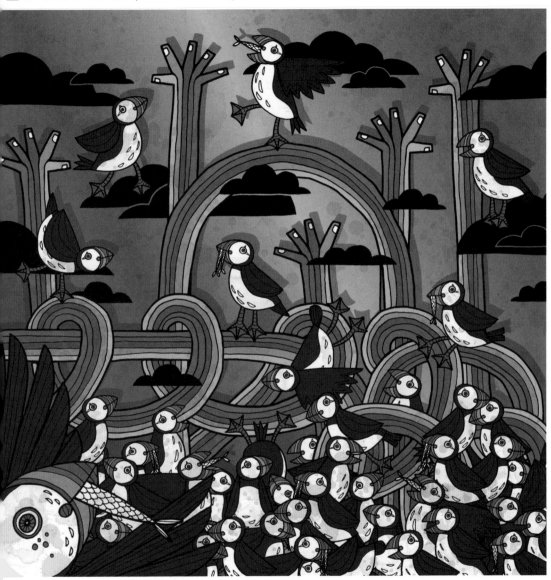

RED FOX *(Vulpes vulpes)*

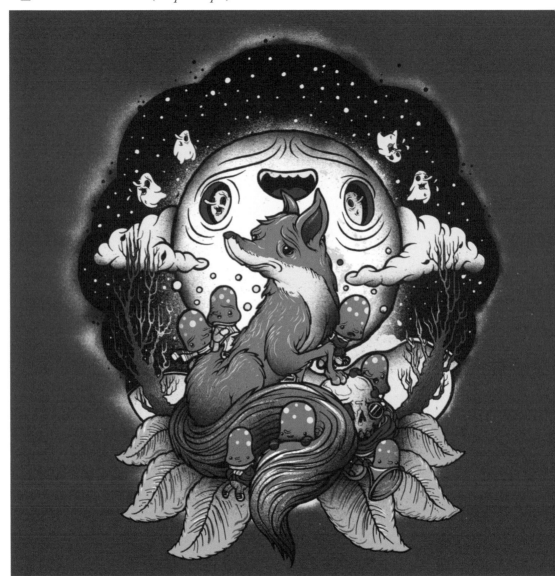

DREW MILLWARD.England

www.drewmillward.com

RINGED SEAL *(Pusa hispida)*

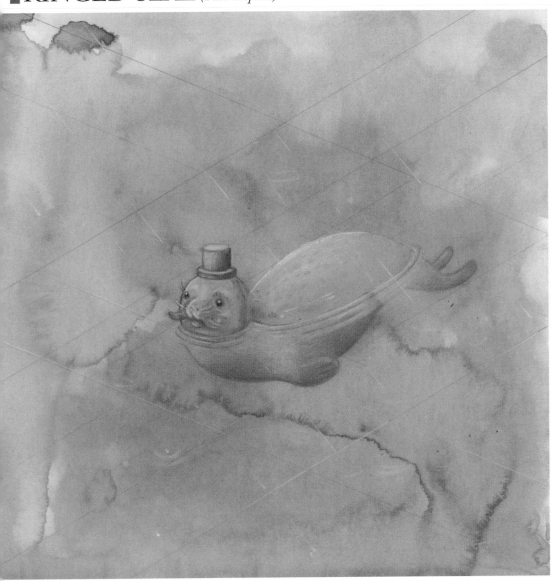

STEFAN GLERUM.Netherlands
www.stefanglerum.com

ROBIN *(Erithacus rubecula)*

IKER AYESTARAN.Spain
www.ikerayestaran.com

ROMANIAN WHITE WOLF *(Canis lupus lupus)*

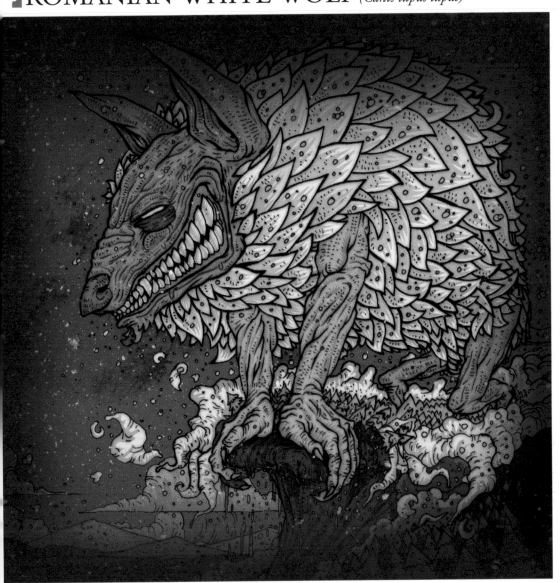

NOPER.Romania
www.noper.ro

ROODBORSTJE *(Muscicapidae)*

SEBASTIAAN VAN DONINCK.Belgium
www.sebastiaanvandoninck.be

ROOSTER *(Gallus gallus)*

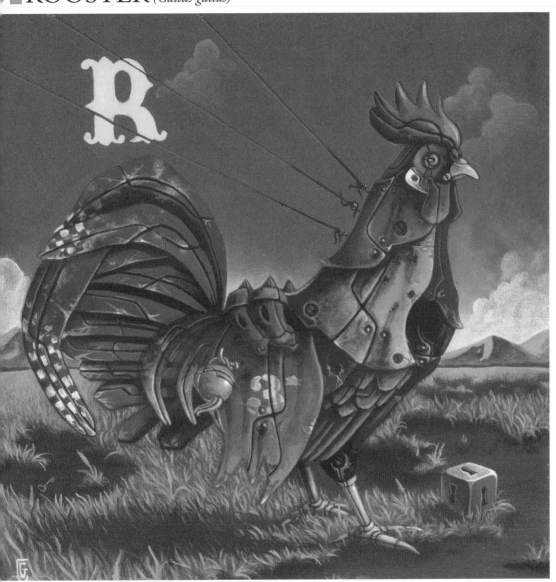

GATO CHIMNEY.Italy

www.steambiz.com

SCHREIBER´S BAT *(Miniopterus schreibersii)*

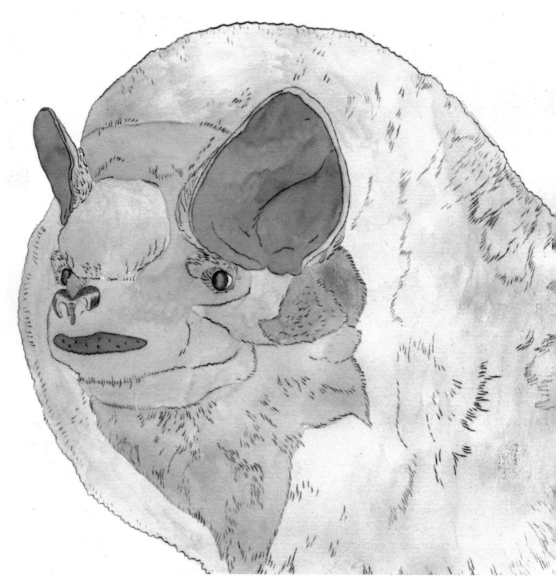

SEAL *(Phoca vitulina)*

GUSTAV DEJERT.Sweeden
www.112oceandrive.com

SEA LION *(Eumetopias jubatus)*

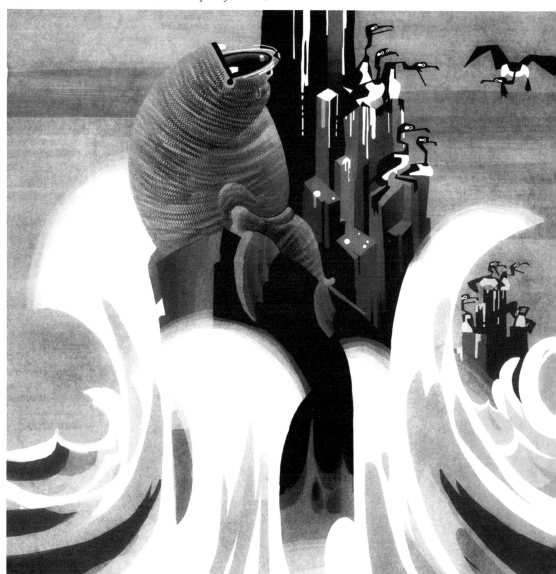

VICTOR MELAMED.Russia
www.mlmd.ru

SHEEP *(Ovis aries)*

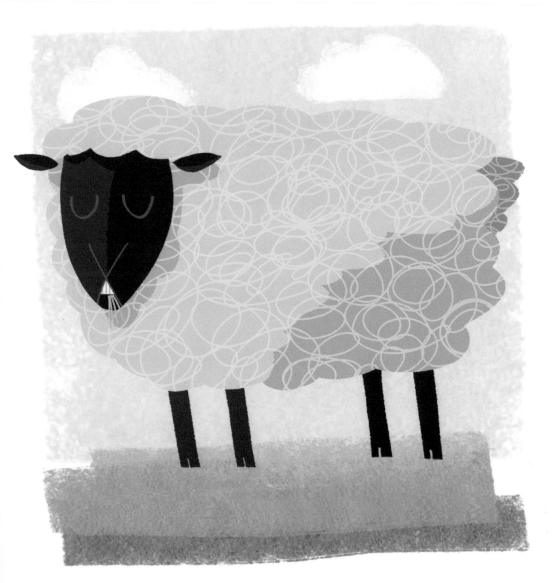

SPARROW *(Passer domesticus)*

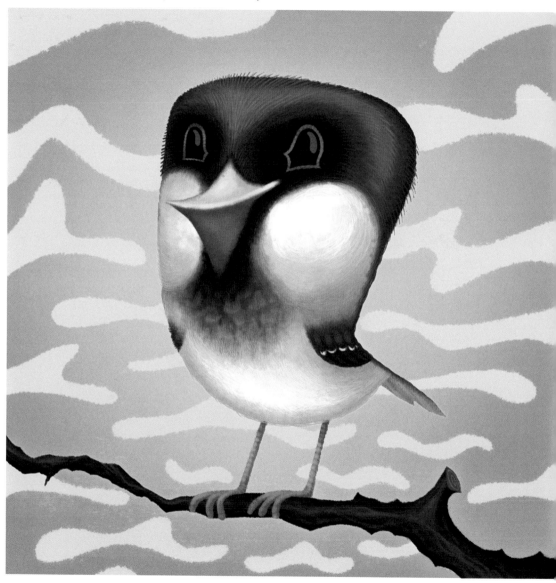

STOJA.Serbia
www.flickr.com/magare

SPERM WHALE *(Physeter macrocephalus)*

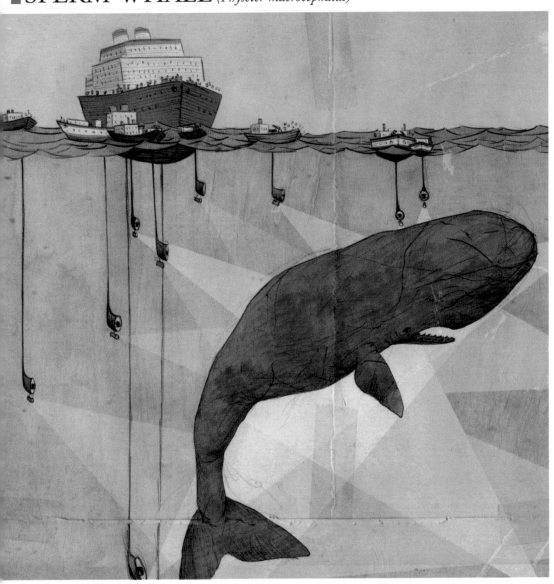

ANDREA OFFERMANN.Germany

www.andreaoffermann.com

SPINY DOGFISH *(Squalus acanthias)*

LIVIA COLOJI.Romania
www.illustration.ro

SQUIRREL *(Sciurus vulgaris)*

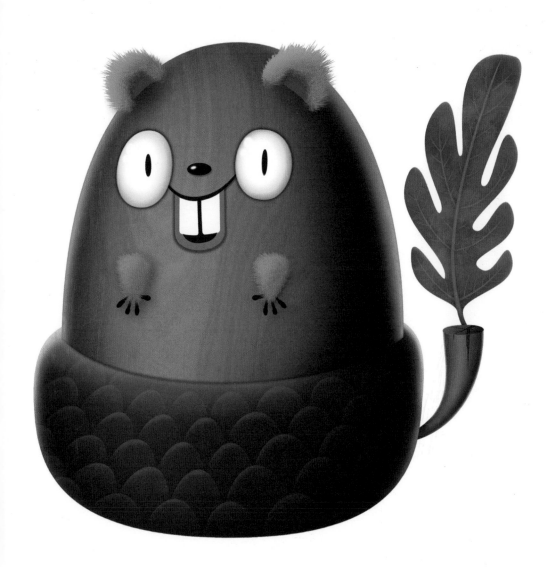

CHRIS GARBUTT.United Kingdom
www.visualphooey.blogspot.com

STAG BEETLE *(Lucanus swinhoei)*

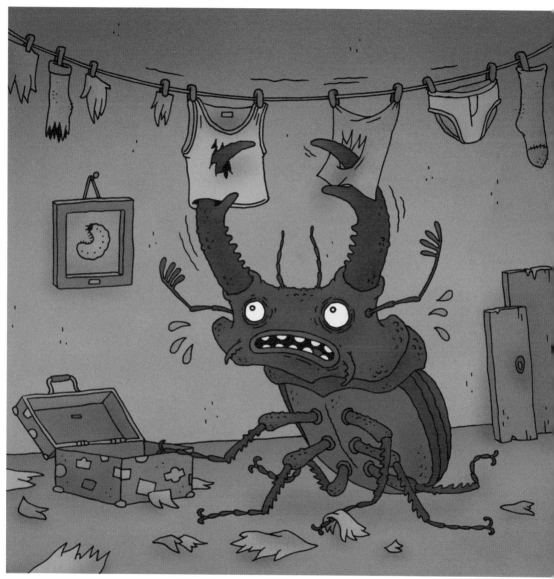

ATZGEREI.Austria
www.atzgerei.com

STORK *(Ciconia boyciana)*

WEASEL *(Mustela nivalis)*

TOYKYO-BUE.Belgium
www.toykyo.be

WHITE STORK *(Ciconia ciconia)*

AGNIESZKA MORAWSKA.Poland
www.designisforpeople.com

WHOOPER SWANS *(Cygnus cygnus)*

MARKKU METSO.Finland

www.markku.groteski.net

WISENT *(Bison bonasus)*

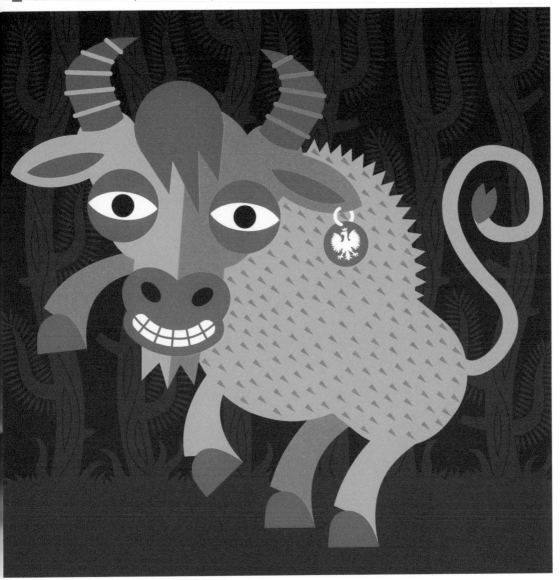

JAN KALLWEJT.Poland

www.kallwejt.com

WOLVERINE *(Gulo gulo)*

AFRICA

 # BABOON *(Papio hamadryas)*

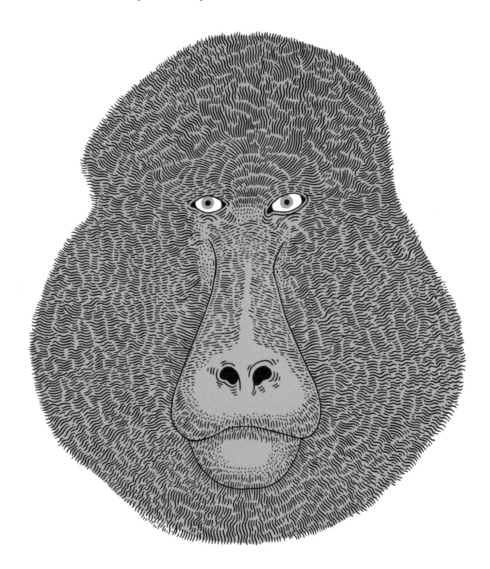

SERGE SEIDLITZ.Kenya
www.sergeseidlitz.com

BLACK EAGLE *(Aquila verreauxii)*

BUSHBABY *(Galago senegalensis)*

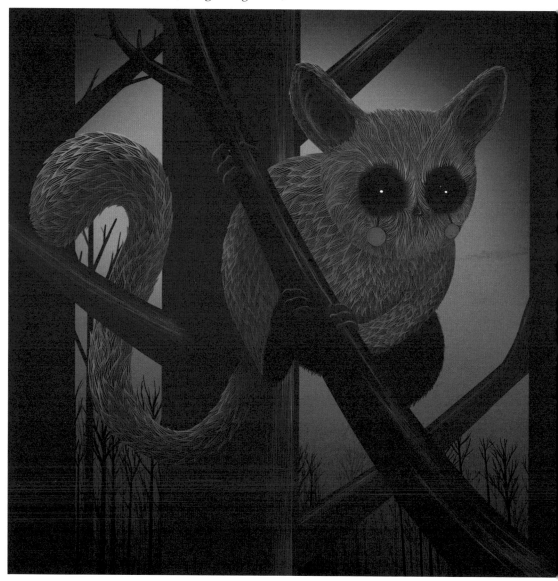

SAD MASCOT.South Africa
www.flickr.com/sadmascot

CHEETAH *(Acinonyx jubatus)*

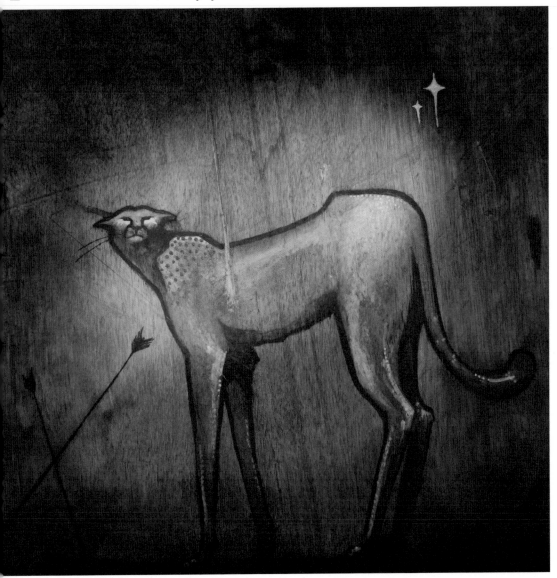

FAITH47.South Africa
www.faith47.com

CROSS RIVER GORILLA *(Gorilla gorilla diehli)*

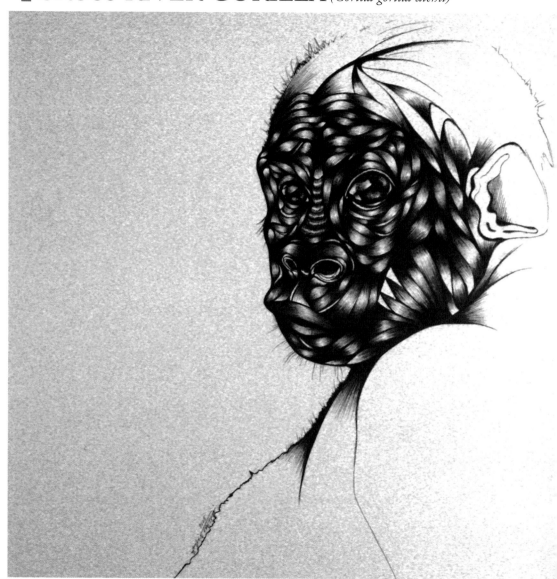

TOYIN ODUTOLA.Nigeria
www.toyino.com

ELEPHANT *(Loxodonta africana)*

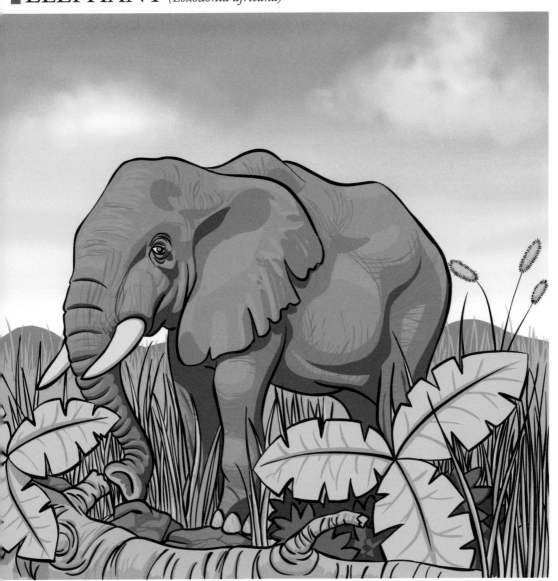

TOLU SHOFULE.Nigeria
www.tolushofule.com

GIRAFFE *(Giraffa camelopardalis)*

KRONK.South Africa
www.flickr.com/kronk

OCEANIA

CORROBOREE FROG *(Pseudophryne corroboree)*

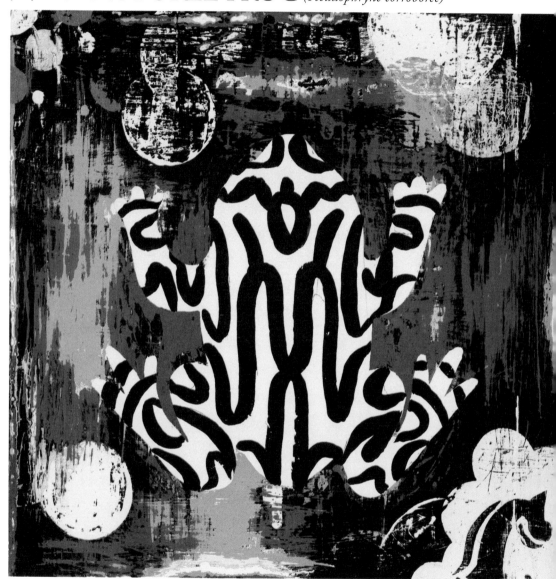

CHRISTOPHER NIELSEN.Australia
www.christophernielsenillustration.com

ECHIDNA *(Zaglossus bruijni)*

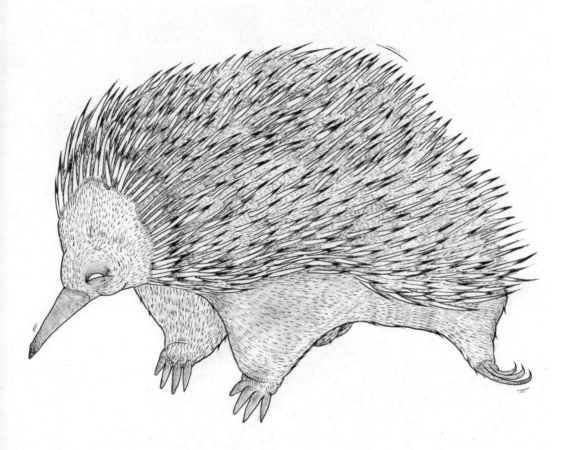

GOULDIAN FINCH *(Erythrura gouldiae)*

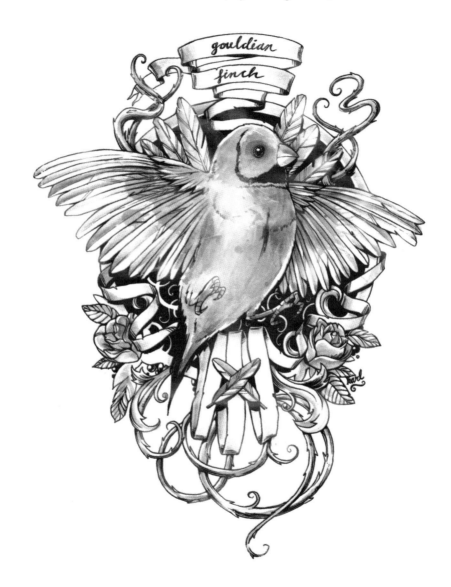

HUMPBACK WHALE *(Megaptera novaeangliae)*

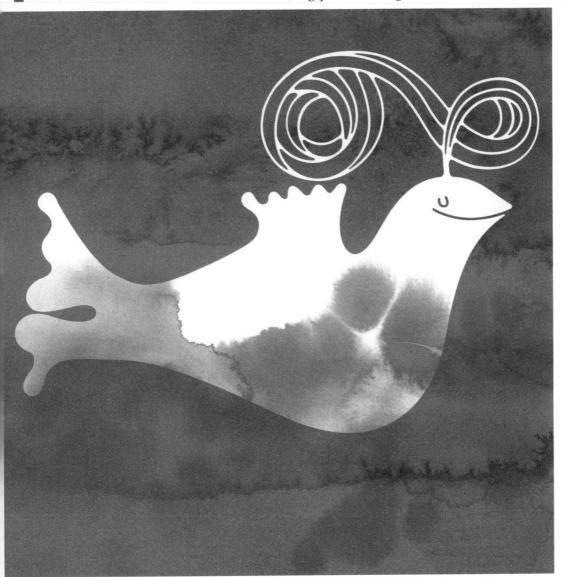

RINZEN.Australia
www.rinzen.com

KANGAROO *(Macropus rufus)*

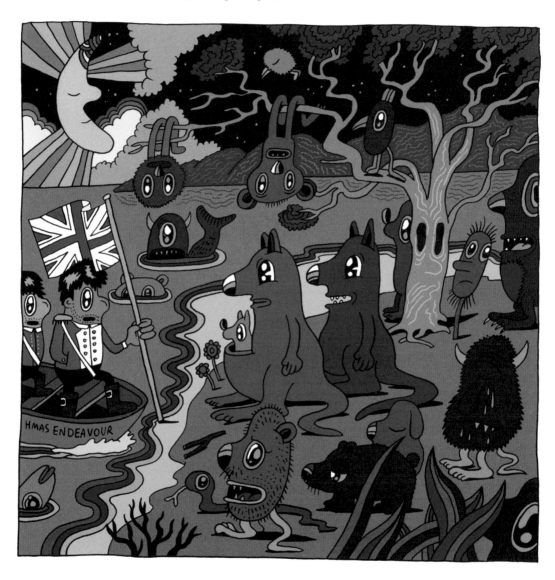

JEREMYVILLE.Australia
www.jeremyville.com

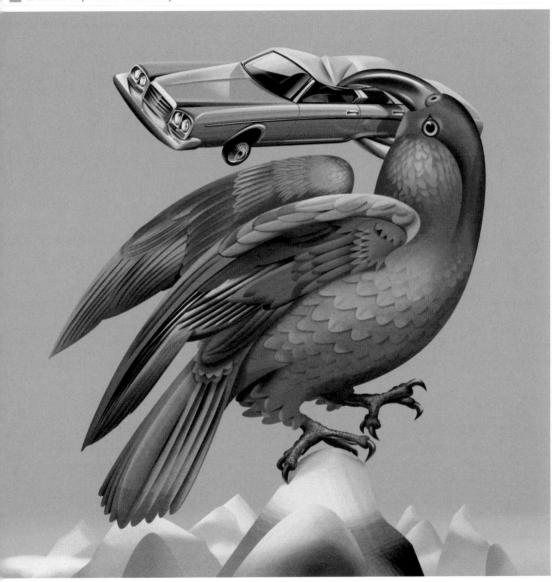

NIGEL BUCHANAN.New Zealand
www.nigelbuchanan.com

 KIWI *(Apteryx rowi)*

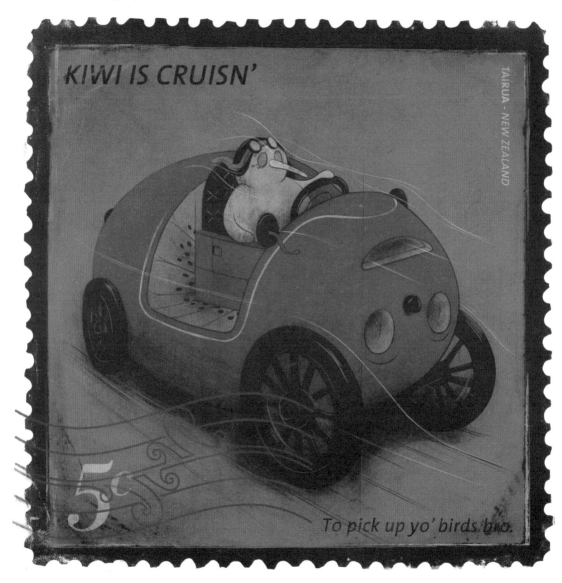

ANDREW ARCHER.New Zealand
www.andrewarcher.com

KOOKABURRA *(Dacelo novaeguineae)*

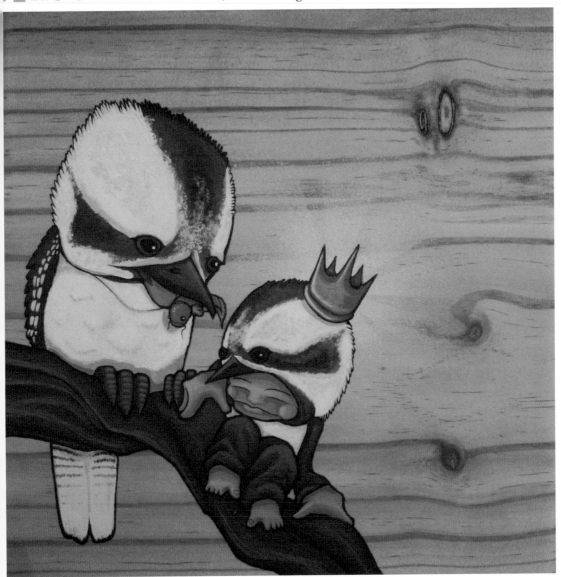

DREW FUNK.Australia
www.drewfunk.com

NUMBAT *(Myrmecobius fasciatus)*

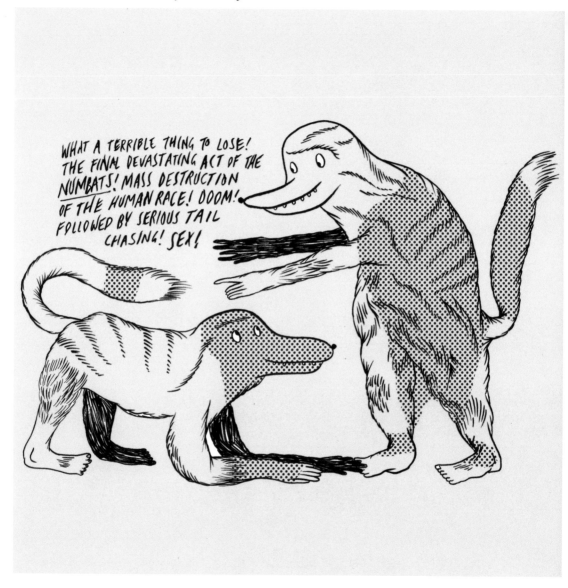

TASMANIAN DEVIL *(Sarcophilus harrisii)*

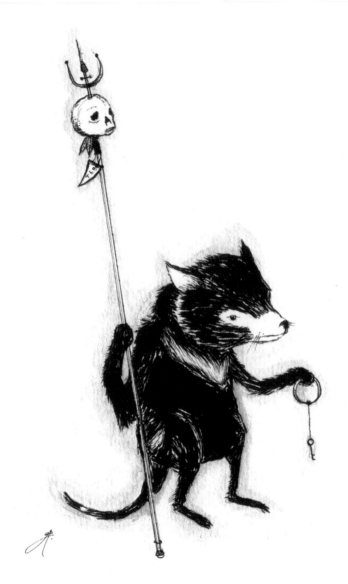

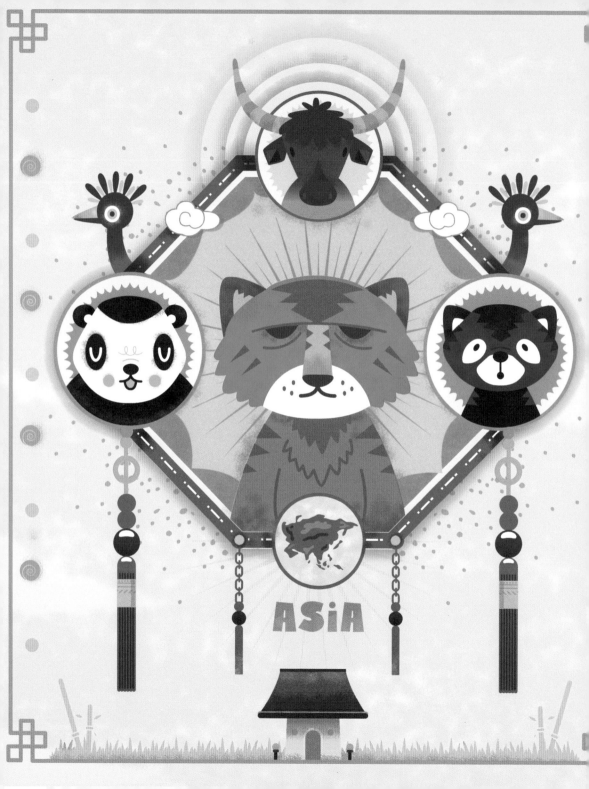

ASIA

AKITA DOG *(Canis familiaris akita inu)*

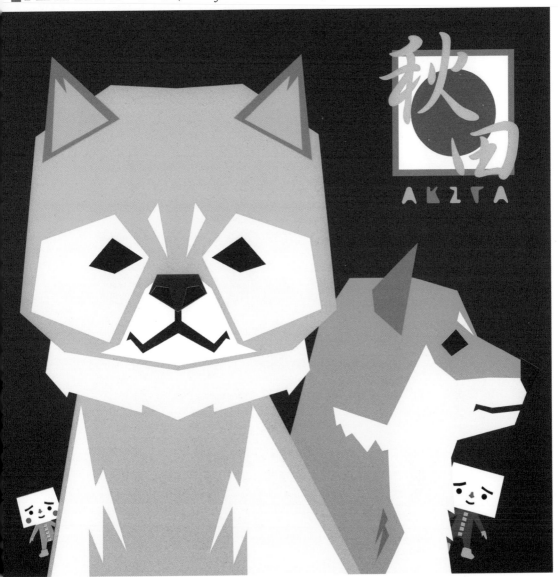

秋田
AKITA

DEVILROBOTS.Japan
www.devilrobots.com

BIRD OF PARADISE *(Cendrawasih)*

CAMEL *(Camelus dromedarius)*

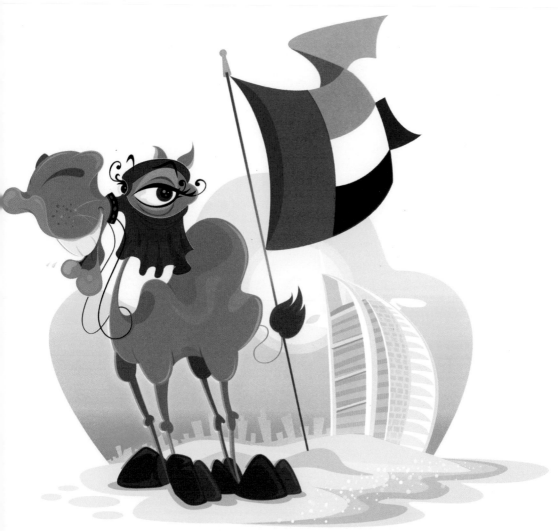

SIRINE MATTA.United Arab Emirates
www.sirinematta.com

CARABAO *(Bubalus bubalis carabanesis)*

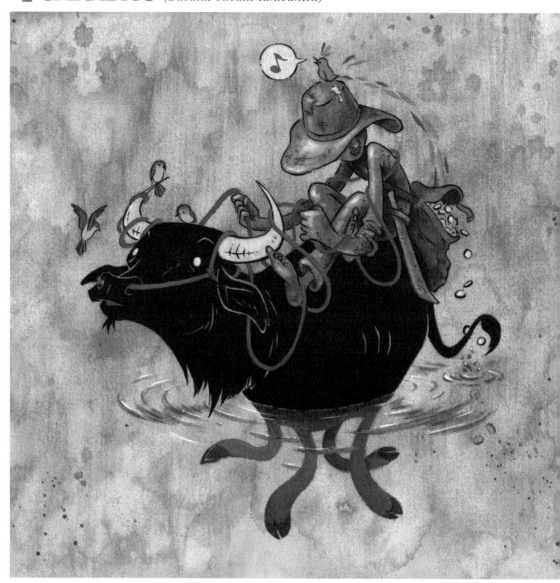

JULIAN CALLOS.Philippines
www.juliancallos.blogspot.com

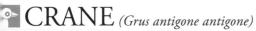

CRANE *(Grus antigone antigone)*

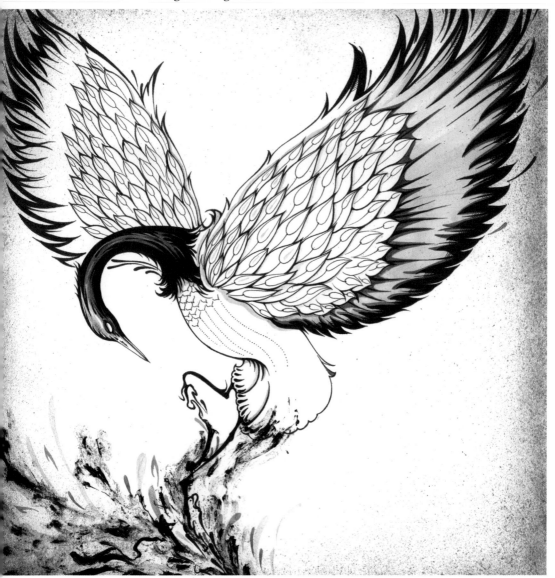

KOKOMOO.China
www.kokomoo.com

FENNEC FOX *(Vulpes zerda)*

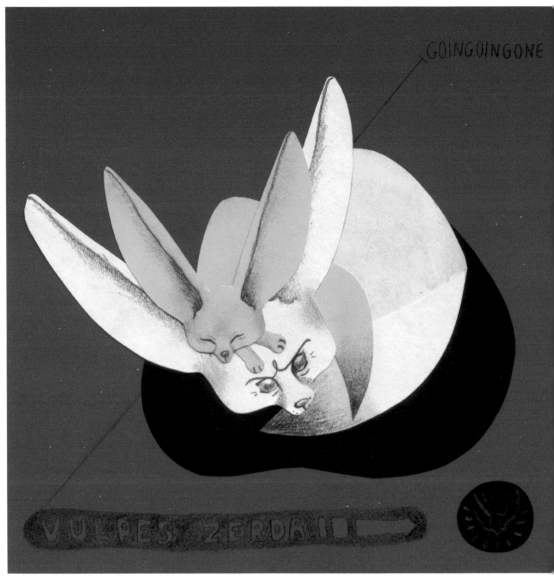

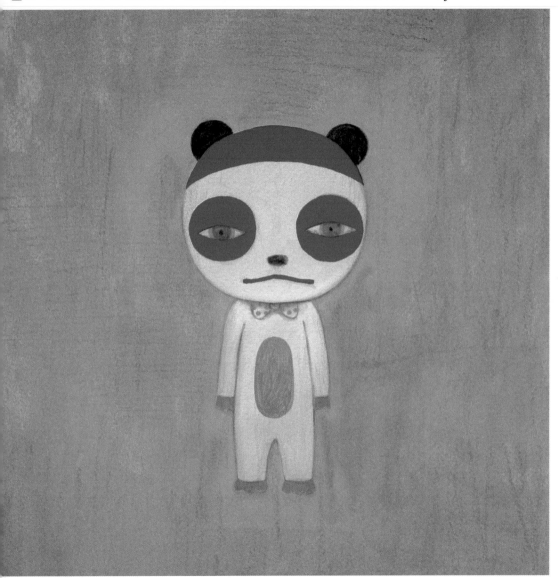

COLA KING.Taiwan
www.colaking.com.tw

FORMOSAN FLYING FOX *(Pteropus dasymallus formosus)*

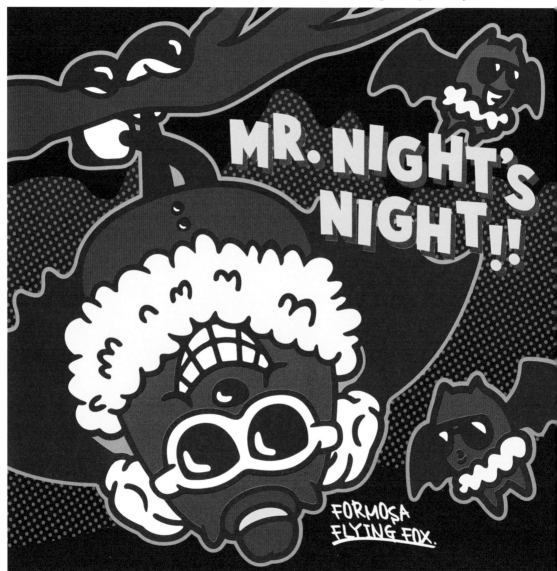

FORMOSAN PANGOLIN *(Manis pentadactyla)*

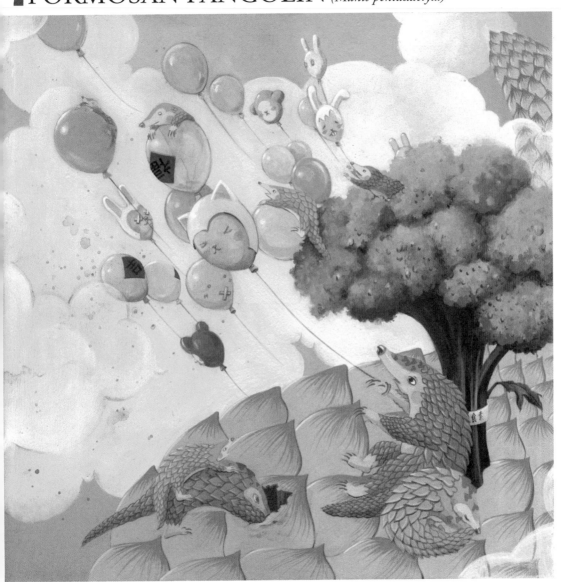

JENI YANG.Taiwan
www.jeniyang.com

GIANT GRENADIER *(Albatrossia pectoralis)*

BOOBOOXXX.Japan
www.boobooxxx.com

GORAL *(Naemorhedus griseus)*

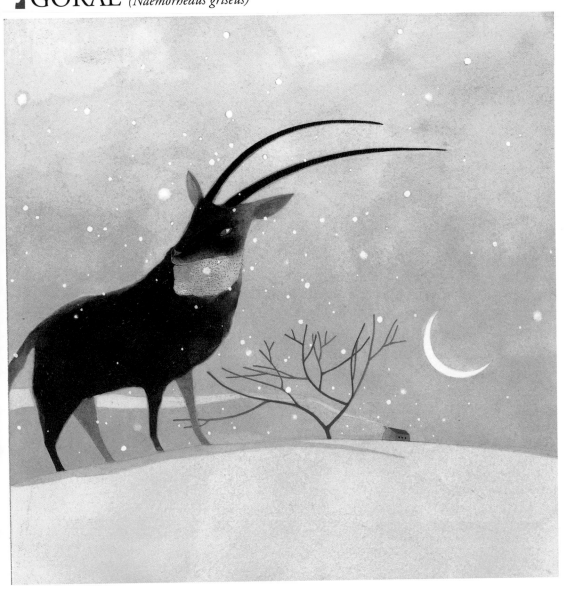

CHUN EUN SIL.Korea
www.chuneunsil.com

GREY WOLF *(Canis lupus)*

BARIS KESOGLU.Turkey
www.bariskesoglu.com

GROUND HORNBILL *(Albatrossia pectoralis)*

ARCHAN NAIR.India
www.archann.net

 # HANWU *(Bos taurus coreanae)*

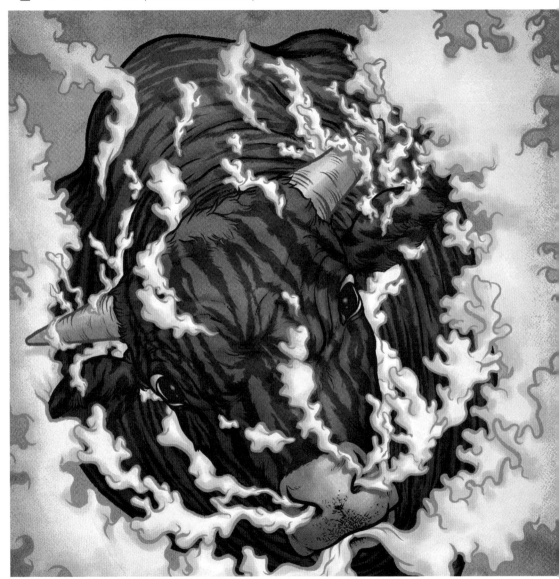

DONGYUN LEE.Korea
www.dongyunlee.com

HOOPOE *(Upupa epops)*

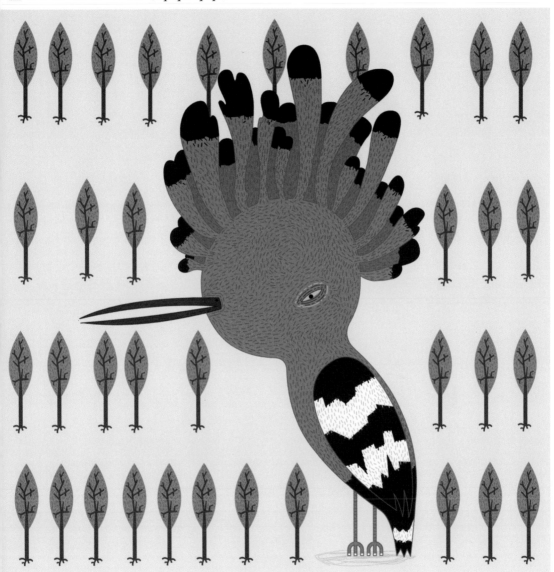

GAL SHKEDI.Israel
www.galshkedi.com

INDIAN CUCKOO *(Cuculus micropterus)*

LOKESH KAREKAR.India

www.locopopo.com

INDIAN PEACOCK *(Pavo cristatus)*

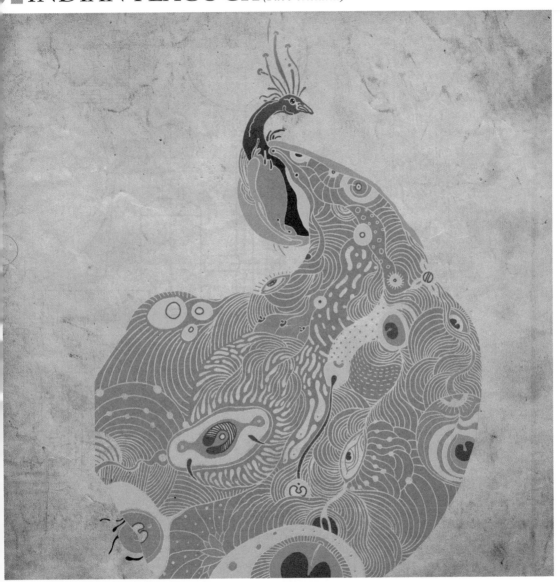

SAMEER KULAVOOR.India
www.sameerkulavoor.com

JAPANESE MACAQUE *(Macaca fuscata)*

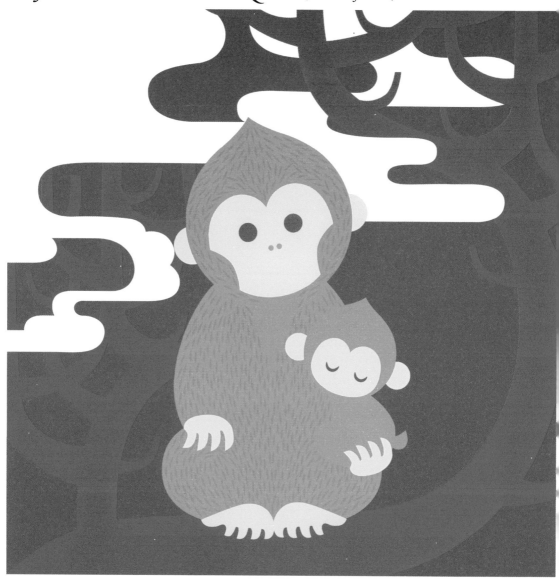

KINPRO.Japan
www.kin-pro.com

JAPANESE BEAR *(Selenarctos thibetanus)*

MOTOMICHI NAKAMURA.Japan
www.motomichi.com

KOI FISH *(Cyprinus carpio)*

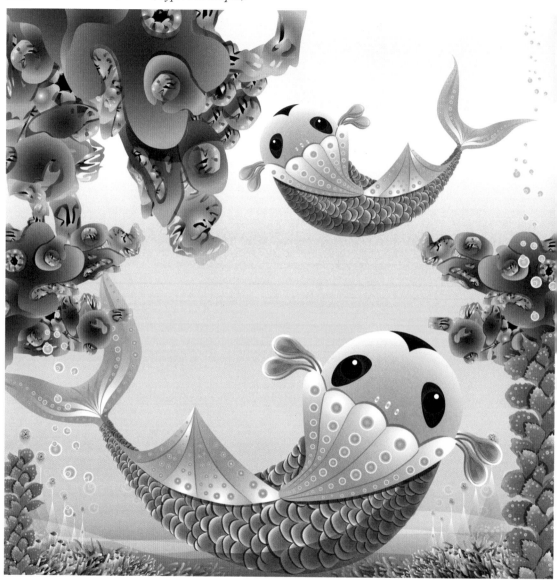

FLOSHIP.Hong Kong
www.studiofloship.com

KO'KO BIRD *(Gallirallus owstoni)*

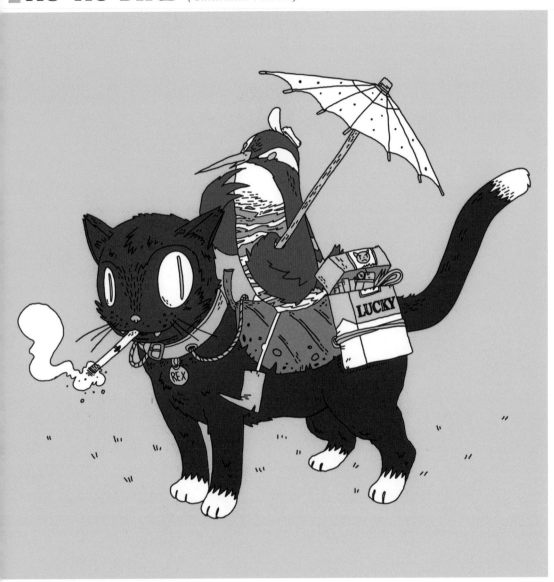

KOMODO DRAGON *(Varanus komodoensis)*

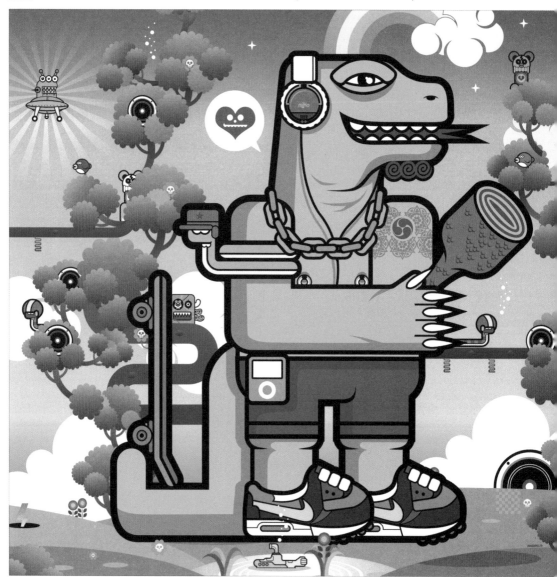

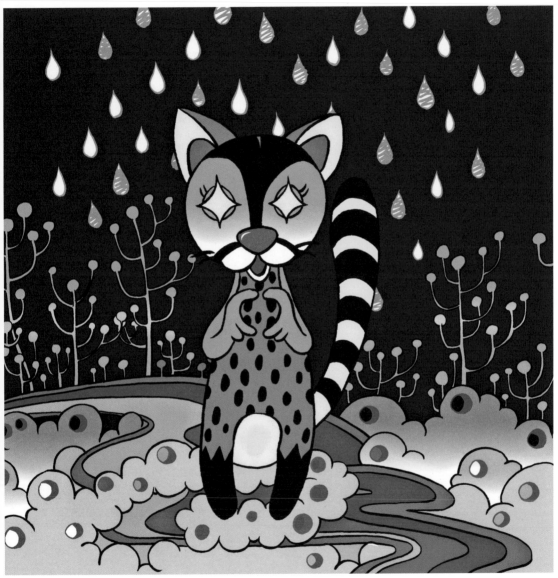

YAYAWOO.Malaysia

www.yayawoo.blogspot.com

LEOPARD *(Panthera pardus)*

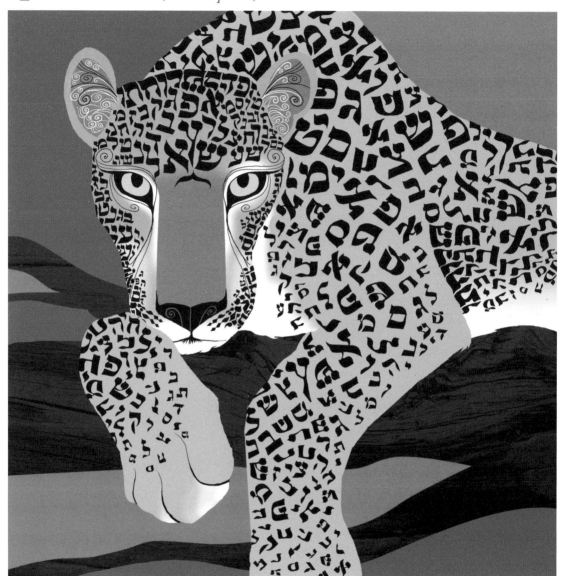

DANCING KANGAROO.Israel
www.dancingkangaroo.com

LONG TAILED MACAQUE *(Macaca fascicularis)*

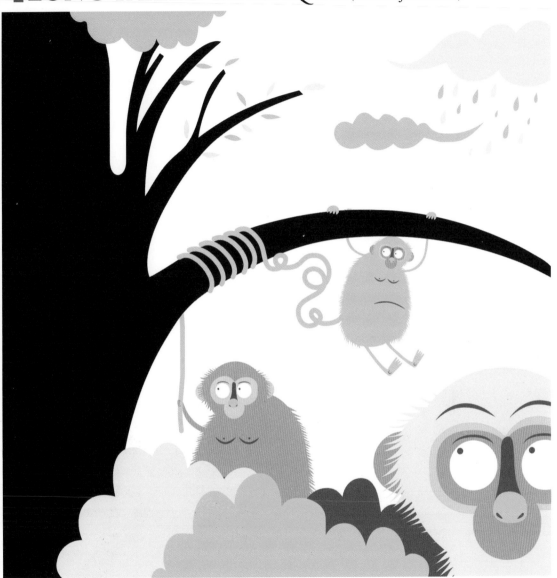

EESHAUN.Singapore
www.eeshaun.com

MAGPIE *(Urocissa erythrorhyncha)*

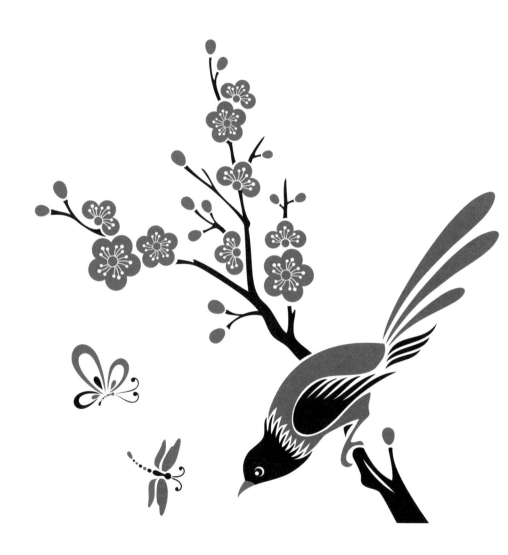

YIYING LU.China
www.yiyinglu.com

MALAYAN TAPIR *(Tapirus indicus)*

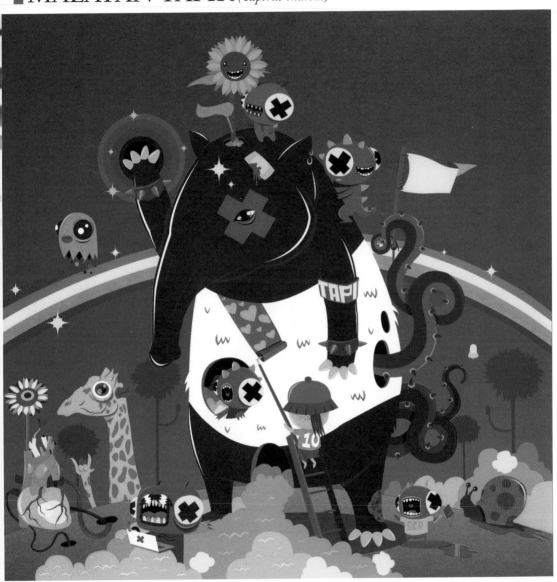

ORKIBAL.Malaysia
www.flickr.com/orkibal

 # MALAYAN TIGER *(Panthera tigris jacksoni)*

MASKED PALM CIVET *(Paguma larvata)*

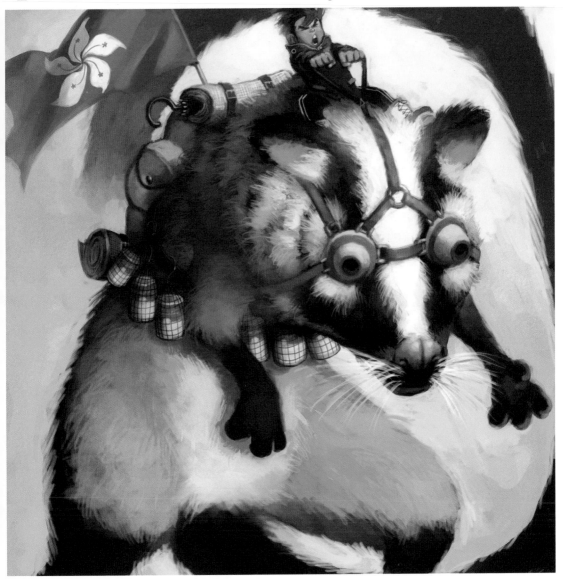

ORANGUTAN *(Pongo abelii)*

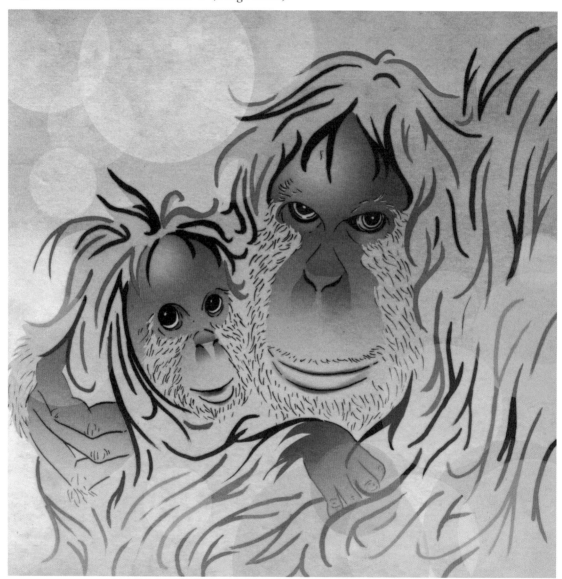

MAYUMI HARYOTO.Indonesia
www.studioshika.com

ORIENTAL GARDEN LIZARD *(Calotes versicolor)*

PANDA *(Ailuropoda melanoleuca)*

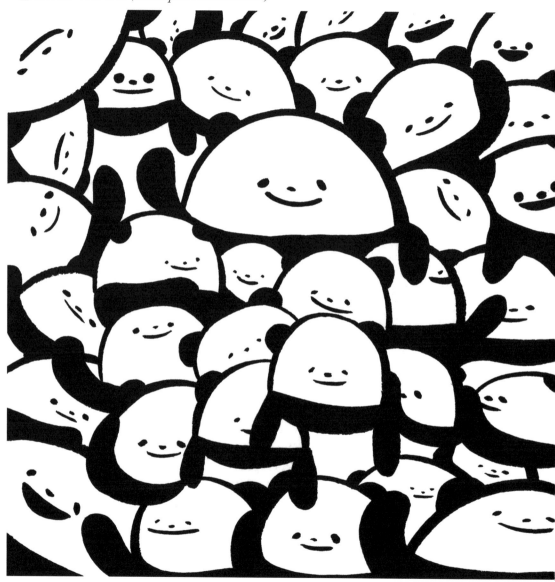

MILKJAR.Hong Kong
www.milkjar.com

PERSIAN CAT *(Felis catus)*

A1ONE.Iran
www.tehranwalls.blogspot.com

RHINOCEROS HORNBILL *(Buceros rhinoceros)*

MICHAEL CHUAH.Malaysia
www.michaelchuahdesign.com

ROMER'S TREE FROG *(Chirixalus romeri)*

SINGAPURA CATS *(Kucinta Felis catus)*

SHEENA AW.Singapore
www.caramelaw.deviantart.com

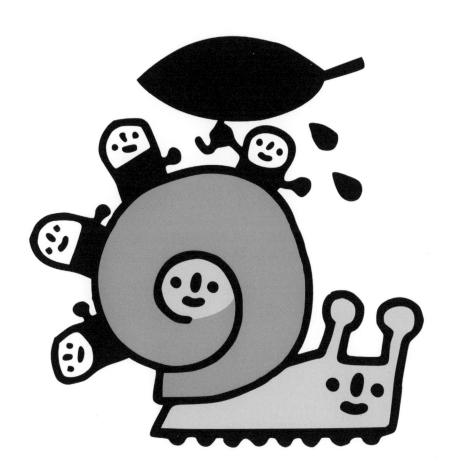

AKINORI OISHI.Japan
www.aki-air.com

SPECTACLED BULBUL *(Pycnonotus erythropthalmos)*

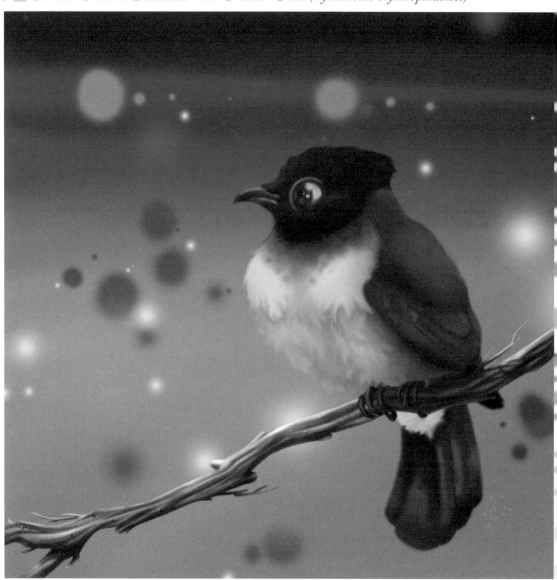

SAUD BOKSMATI.Libano
www.mrbreadcrumbs.blogspot.com

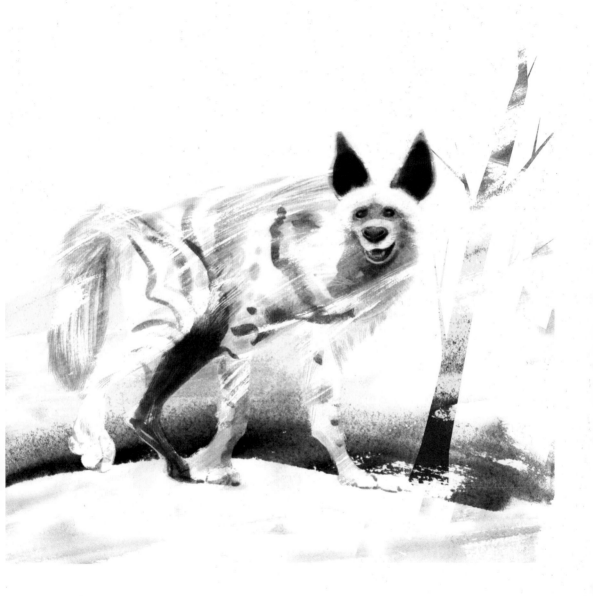

SUMATRAN RHINOCEROS *(Dicerorhinus sumatrensis)*

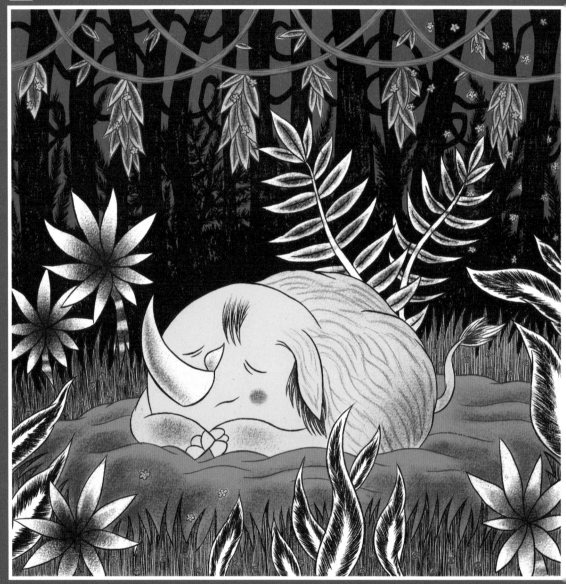

AYA KAKEDA.Japan
www.ayakakeda.com

SUMATRAN TIGER *(Panthera tigris sumatrae)*

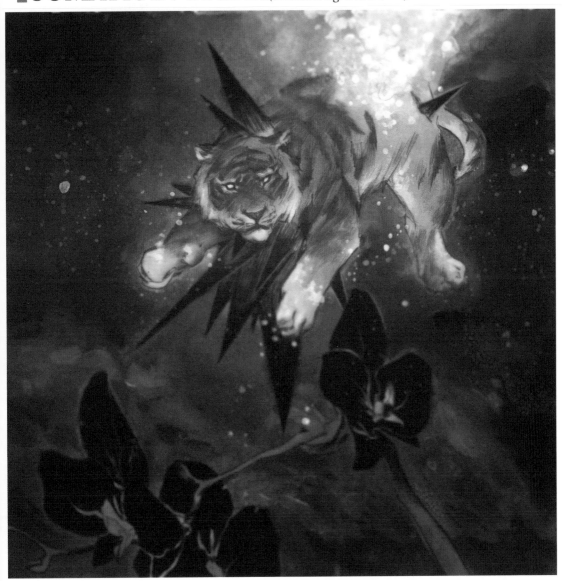

TESSAR LO.Indonesia
www.tessarlo.com

TOKI *(Nipponia nippon)*

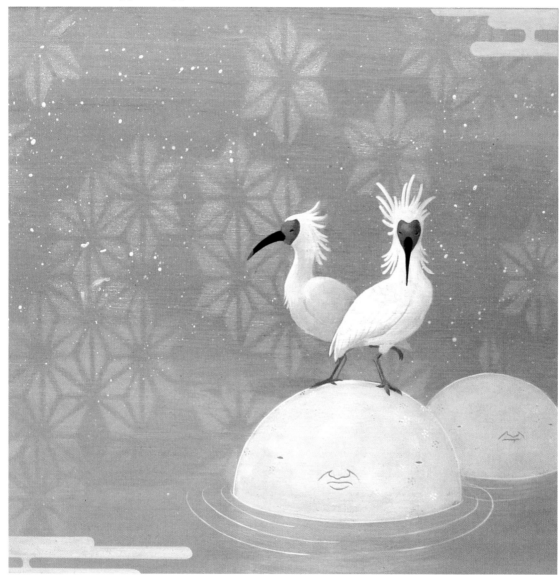

YOSKAY YAMAMOTO.Japan
www.yoskay.com

VAN CATS *(Turkish Van Felis catus)*

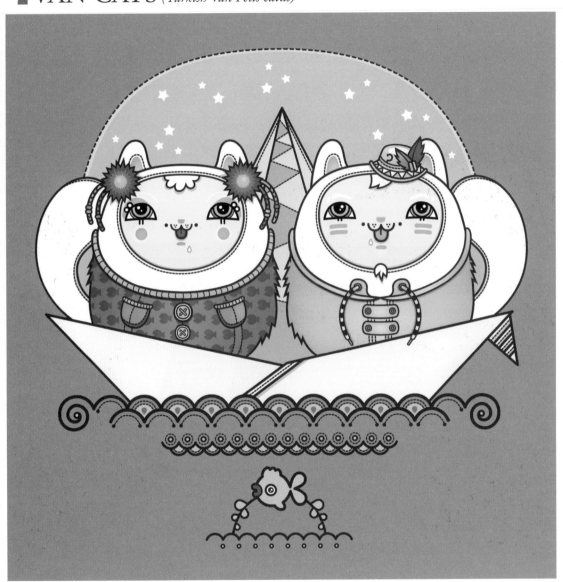

BLUE MAGENTA.Turkey
www.bluemagenta.blogspot.com

WHALE SHARK *(Rhincodon typus)*

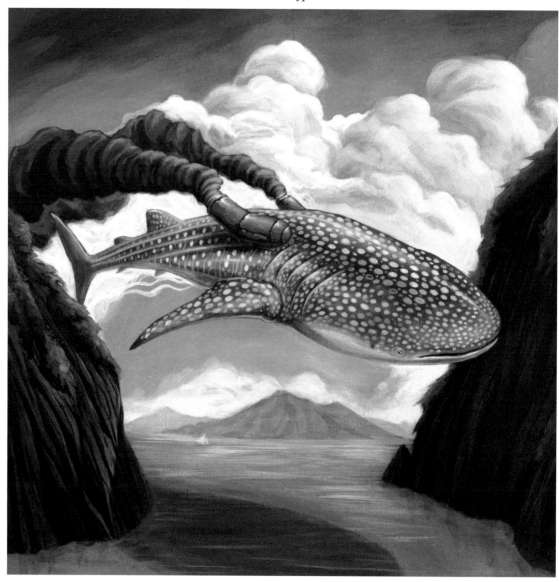

ROLAND TAMAYO.Philippines

www.rolandtamayo.com

WILD DOG *(Cuon alpinus)*

SHEN PLUM.Hong Kong
www.shenplum.com

WILD CAT *(Felis silvestris)*

TOUMA.Japan
www.touma.biz

.THE ARK ARTISTS.

DGPH and THE ARK PROJECT WOULD LIKE TO THANK
.THE ARTISTS FROM ALL OVER THE WORLD ILLUSTRATING IN THE NAME OF NATURE.

SOUTH AMERICA
Alberto Montt
Alex Dukal
Blirp
Camilo Bejarano
Chamarelli
Christian Montenegro
Conrad
DGPH
Diego Medina
Elisa Chavarri
Fran
Gaston Caba
Igor Bastidas
João Ruas
Julian Gallasch
Kapitan Ketchup
Lorena Alvarez
Maria Luisa Isaza
Mauricio Pierro
Miss Ruido
Misprinted Type
Mopa
Parquerama
Piktorama
Pilar Berrio
PO!
Renato Faccini
Super DD

CENTRAL AMERICA
Andre Gribble
Chris Silva
Dendoo
Edel Rodriguez
Eduardo Sarmiento
Edwin Ushiro
Leo Lammie
Lou Pimentel
Monfa

NORTH AMERICA
64colors
Alberto Cerriteño

Alexei Vella
Apak
Arbito
Cecy Meade
Chris Hosmer
Dundo
Ed Kwong
Friends With You
John Vogl
Johny Yanok
Josh Keyes
Julie West
Ken Garduno
Luke Ramsey
Meg Hunt
Meomi
Micah Lindberg
Michael Wandelmaier
Mincing Mocking Bird
Mr Kone
Nook
Robotsoda
Scotty Reifsnyder
Steve Mack
Van Beater

EUROPE
Agniezka Morawska
Aleksander Kostenko
Allan Deas
Ana Galvan
Andrea Offermann
Atzegerei
Ben Newman
Bomboland
Buro Destruct
Camellie
Chris Garbutt
Claire Scully
Collin Van Der Sluijs
Digital Rampage
Graham Corcoran
Drew Millward
Easy Hey
Ekiselev

Fons Schiedon
FRM Kid
Fupete
Gato Chimney
Geoffrey Skywalker
Gordei
Gustav Dejert
Heiko Muller
Hello Freaks
Human empire
Iker Ayestaran
Jan Kallwejt
Jon Burgerman
Jorn Kaspuhl
Juju´s Delivery
Julie Fletcher
Kat Leuzinger
KOA
Koralie
Kristiana Parn
Lennard Schuurmans
Linde Design
Lints
Livia Coloji
Madsberg
Maja Veselinovic
Malota
Mark Verhaagen
Markku Metso
Maroto
Mashuska
Michael Hacker
Mikko Walamies
Muro
Niark1
Nishant Choksi
Noper
Onesidezero
Oreli
Papriko
Paulo Arraiano
Peachbeach
Petra Stenfankova
Puño
Raquelissima

Rudpunk
Saddo
Sandra Juto
Sauerkids
Sebastiaan Van Doninck
Stefan Glerum
Steve Simpson
Stoja
Studio Kxx
Tado
The Keld
Tomi Slavtomic
Tougui
Toykyo-Bue
Victor Melamed
Ville Savimaa
Wundergrafiks
Yupiland
Zablotska
Zeptonn

AFRICA
Faith47
Kronk
Sad Mascot
Serge Seidlitz
The Motel
Tolu Shofule
Toyin Odutola

OCEANIA
Andrew Archer
Christopher Nielsen
Cupco
Drew Funk
Ghostpatrol
Jeremyville
Monaux
Nigel Buchanan
Nior
Rinzen

ASIA
Aya Kakeda
A1One

Akinori Oishi
Archan Nair
Baris Kesoglu
Benqwek
Blue Magenta
BoobooXXX
Chun Eun Sil
Cola King
Cuson
Dancing Kangaroo
Devilrobots
Dongyun Lee
Driv
Eeshaun
Filter 017
Floship
Gal Shkedi
Giant Robot
Go Tam
Graphicairlines
Indieguerillas
Irine
Jeni Yang
Joshua Agerstand
Julian Callos
Kinpro
Kokomoo
Lokesh Karekar
Mayumi Haryoto
Michael Chuah
Milkjar
Motomichi Nakamura
Orkibal
Roland Tamayo
Sameer Kulavoor
Saud Boksmati
Sheena Aw
Shen Plum
Sirine Matta
Tessar Lo
Touma
Yayawoo
Yiying Lu
Yoskay Yamamoto

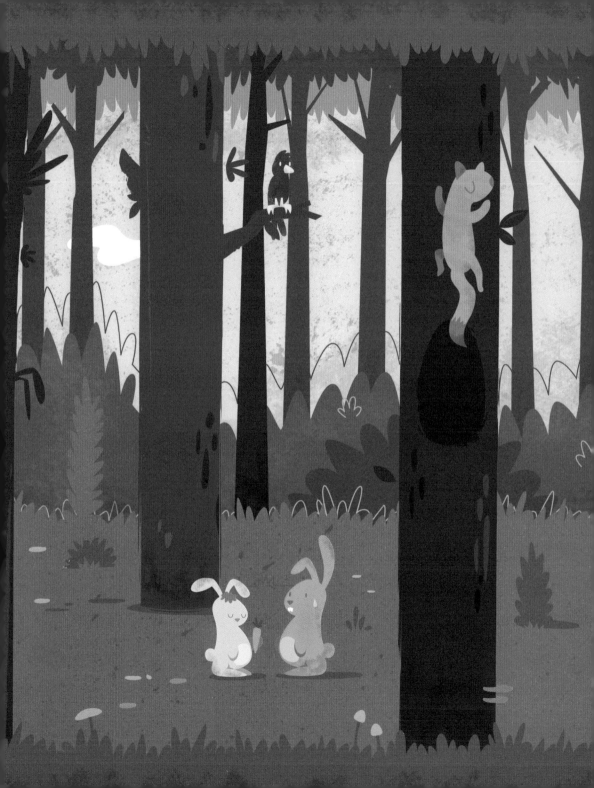

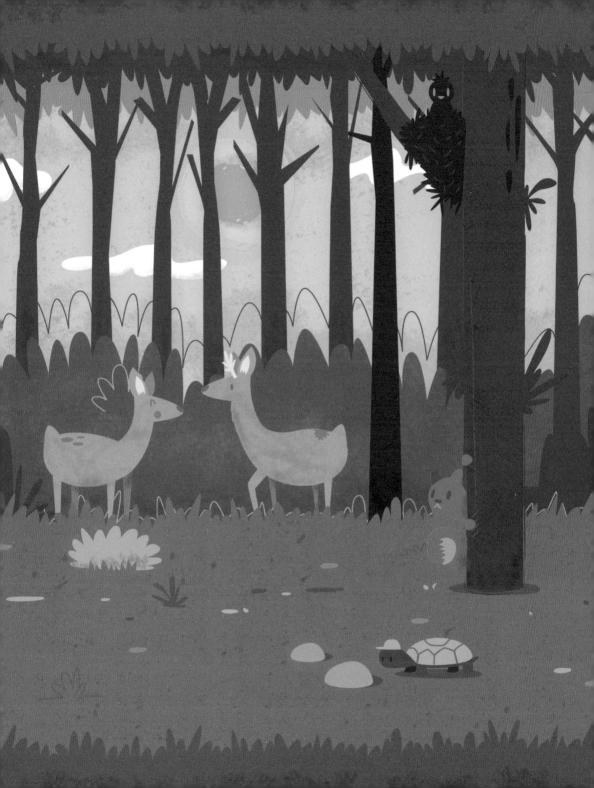

The Ark Project

ISBN: 978-988-18470-1-0
http://idnworld.com/books/?id=ark

Edited and designed by DGPH
Authors: Andres Vaisberg, Diego Vaisberg, Martin Lowenstein
In collaboration with: Natalia Libman (Noah´s book translation)

DGPH Design & Visual Arts Studio
W: http://www.dgph.com.ar
E: info@dgph.com.ar

2009 First Edition
Published by Systems Design Limited
The Publisher of IdN Magazine
4/F, Jonsim Place
228 Queen's Road East
Wanchai, Hong Kong
T: +852 2528 5744
F: +852 2529 1296
E: info@idnworld.com
W: http://idnworld.com